Painting Watercolor Portraits that Glow

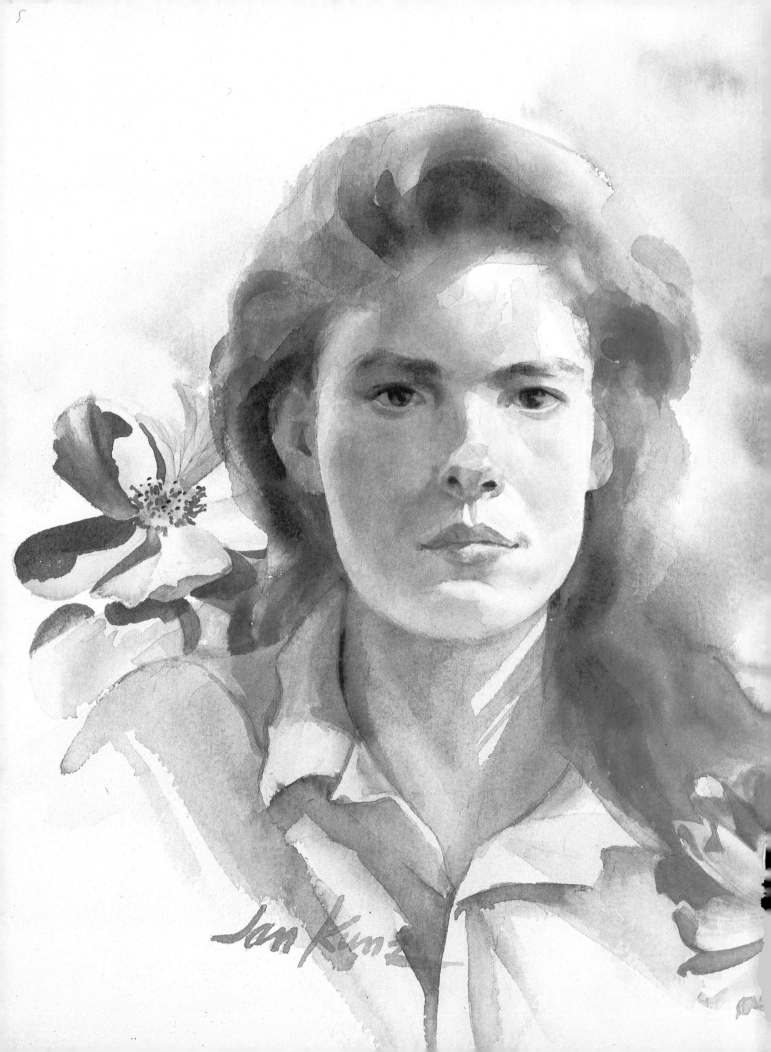

Painting Watercolor Portraits that Glow

Jan Kunz

NORTH LIGHT BOOKS

Cincinnati, Ohio

94 93 92 6 5 4

Library of Congress Cataloging-in-Publication Data

Kunz, Jan.
 Painting watercolor portraits that glow.

 Bibliography: p
 Includes index.
 1. Watercolor painting—Technique. 2. Portrait painting—Technique. I. Title.
ND2200.K86 1989 751.42'242 88-35620
ISBN 0-89134-291-5

Edited by Greg Albert
Designed by Clare Finney

Dedicated to the people who have made a difference:
Lester M. Bonar, Reynold Brown, Irma Eubanks

Creating a book is a team effort, and so I extend my sincere thanks to the rest of the team:

To editor Greg Albert, who made the book possible, and whose unfailing enthusiasm and skillful direction have made the work almost fun.

To production editor Kathy Kipp, who has kept everything together and created organization out of a jumble of art and copy.

To the fine artists who have generously contributed their work.

To the many friends who, with unfailing good humor, have been my models.

And finally to my husband Bill, who has become a great cook, experienced proofreader, and who once again has proved himself to be my dearest friend.

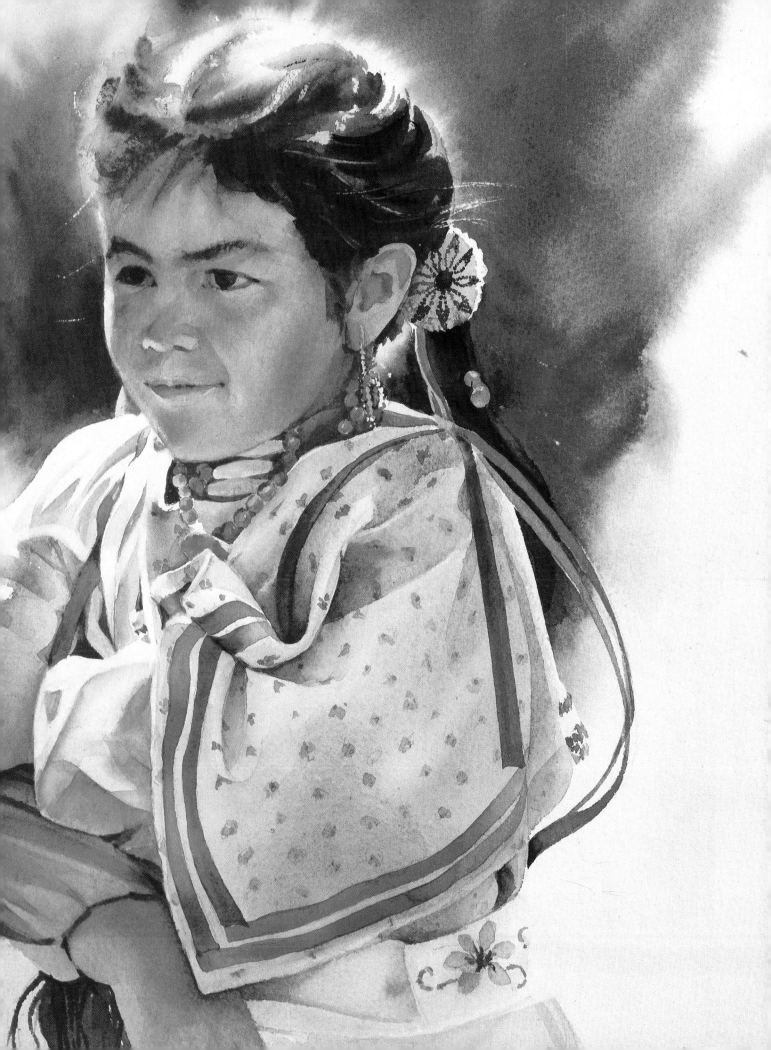

Contents

Introduction 1

Before We Paint 2

1. The Basic Head

One/Drawing: The First Step 13

The Structure of the Head 14

Blocking In the Head 16

Heads in Various Positions 18

Features 22

Dos and Don'ts 26

Using Tracing Paper 28

Two/The Illusion of Three-Dimensional Form 30

One Source of Light 32

The 40 Percent Rule 33

The 40 Percent Rule at Work 34

Demonstration: An Indian Youth 36

Demonstration: A Businessman 40

Three/Seeing Light and Color 44

Laws of Light 46

Light and Shadow 48

Color and Value 50

Properties of Watercolor Pigments 54

The Color Wheel 55

Brilliant Darks 56

Skin Tones 58

Reflected Light 59

Demonstration: Pretty Penny 60

Demonstration: A Businesswoman 62

Demonstration: Aunt Rosemary 66

2. The Portrait

Four/Looking at Your Subject 72

Live Model or Photo 74

Posing a Model 75

Selecting a Photograph 76

What to Look For 78

Seeing Your Model 80

Five/Composing the Portrait 82

A Pathway for the Eye 84

The Center of Interest 86

The S.A.T. Sketch 87

Six/Painting the Portrait 88

The Final Drawing: Jon-Marc 90

Applying Color: Jon-Marc 91

The Final Drawing: Pat 96

Applying Color: Pat 97

3. Portrait Studies

Demonstration: Young Black Man 104

Demonstration: Little Girl 108

Demonstration: Young Boy 112

Demonstration: Elderly Woman 116

Practice Portraits 120

Portrait Painter's Questionnaire 126

10 Steps to a Successful Portrait 127

4. Gallery

Conclusion 138

Practice Drawings 140

Bibliography 146

Index 148

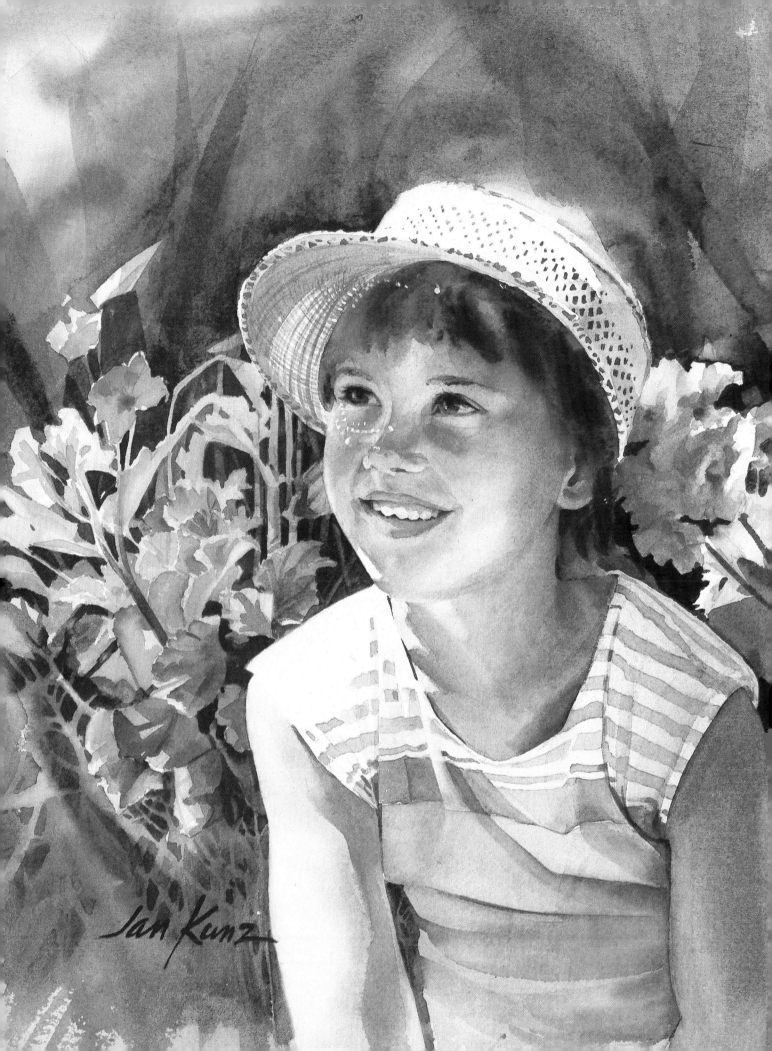

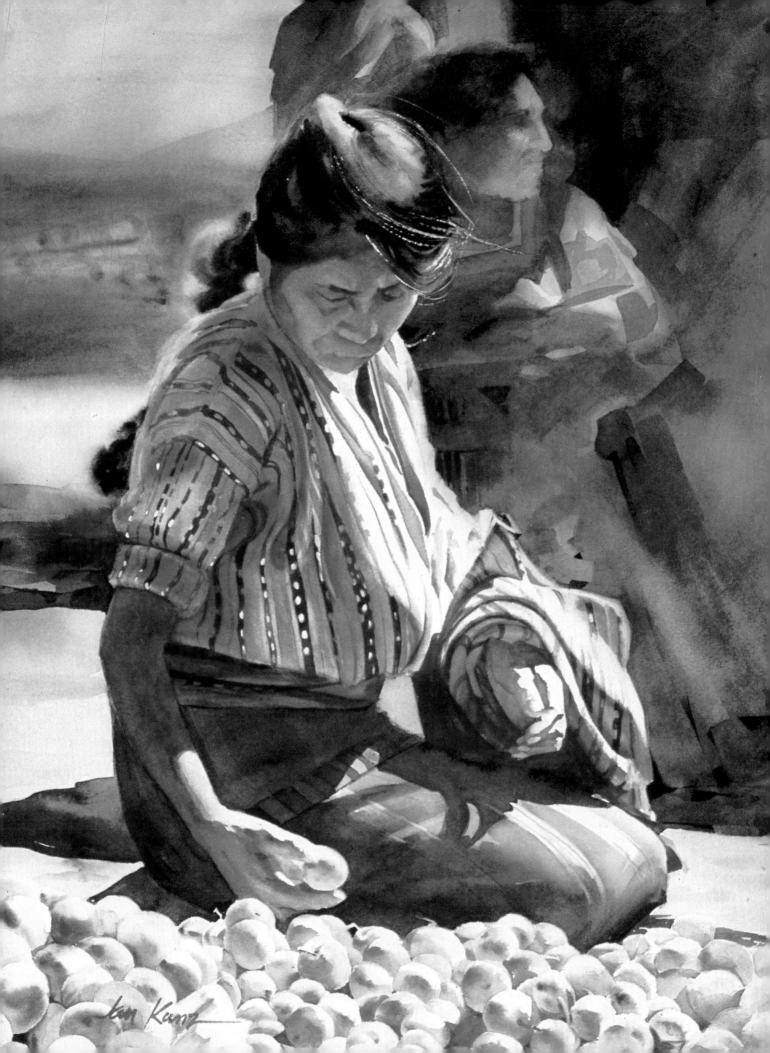

Introduction

I once attended a watercolor class in which a bewildered student asked the instructor, "Where do we start?" A bit dismayed, the teacher replied, "Start anywhere you feel sure of yourself." After a moment, the student looked up again and said, "OK . . . I've signed my name. Now what?"

I hope this book will give you some answers to the question of where to start in painting watercolor portraits, and where to go from there.

Painting in watercolor is exciting because it can move on its own, and challenging because it does move, all too often, where you don't want it. Once you begin to paint in watercolor it becomes addictive and you're happily hooked into a lifetime of learning what makes watercolor tick. So assuming you are one of us who is lost to the medium, or someone who may soon be, how does this sound for a challenge—painting watercolor portraits that glow?

I know from experience you have probably already thumbed through these pages, and you may have noticed this looks like a "hands-on" workbook. That's exactly what it's intended to be. Before long, I hope these pages are spotted with the paint you've splashed on them from practicing every exercise.

Before we talk about how best to use this book, I think you should know something about my background, because my experiences are reflected in my approach to portraiture. I began my career as a commercial artist. There isn't much glamour to commercial art; the prime objective is to sell the product. However, this experience taught me one valuable lesson. I learned to analyze the project at hand, and to work out obvious problems *before* they happen. This may explain why,

when I decided to paint watercolor portraits, I looked for a simple method to plan a successful painting even before I started to put paint on paper. This method works for me, but I have never claimed that mine is the only approach. The goal is not what approach you take, the goal is painting fresh, glowing portraits!

The first section of this book is full of the basic information you need to draw the head in any position. Next you'll see how to create the illusion of a solid form, and then, by following the 40 percent rule, which tells you that shadows are 40-percent darker than the areas in light. Then you'll discover how to put the glow of warm sunlight into your portraits by learning the laws of light. A few simple principles will enable you to make portraits filled with radiant color. This information is important no matter what subject you paint.

The first demonstrations are in values of gray. This is for a good reason. You should concentrate all your attention on getting the darks properly placed. Remember, color expertise will come with practice, but all the color in the world will not help if the value relationships are incorrect.

Many of the demonstrations in this book are in the form of "paint-along exercises." They are not intended to be works of art. It may be easier to follow the painting process if we both start from the same drawing. You'll find some of my sketches at the back of the book, so you might consider copying these line drawings onto your watercolor paper and painting along with me.

I will describe my entire painting process by showing you how I painted two portraits, one of my friend Pat, a vivacious young woman, and Jon-Marc, an ener-

getic boy of four. How I posed my models, how I composed the paintings, how I did accurate preliminary drawings, and finally how I applied the paint are all described in Section Two.

In the next section, I show how the procedure detailed in the previous section is applied to four very different subjects. Also included are three more practice portraits that you can use to develop your own skill. A concise summary of my method with a series of key questions portrait artists should ask themselves as they work can be found on pages 126 and 127. You may want to place a copy of them in a prominent place in your studio so you can refer to them often until they are a permanent part of your methods.

In the final sections, I have a gallery of paintings by other artists with comments on why I like them. The book concludes with six of the drawings I used for the demonstrations reproduced full size that you can use to follow along with me, and a list of the books that I think are very useful for the portrait painter.

Even if you have never attempted a portrait before, I think you may be surprised at how well you do. The important thing is to enjoy yourself. And remember, the more you paint, the better painter you become. It may take talent or aptitude to get you started, but it takes practice and patience to get the rest of the way.

Good luck!

Jan Kunz

1

Before We Paint

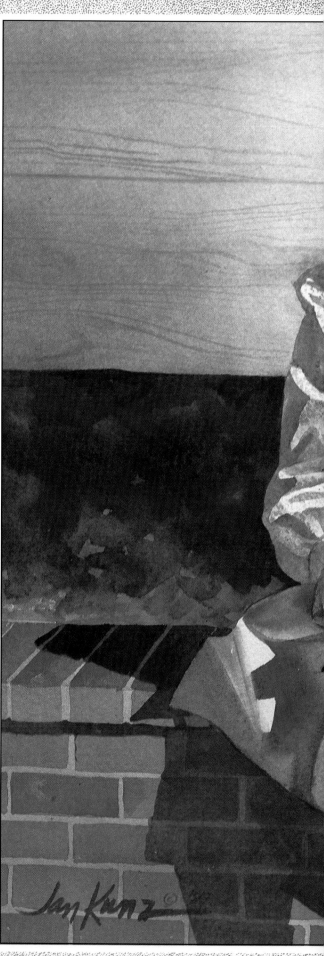

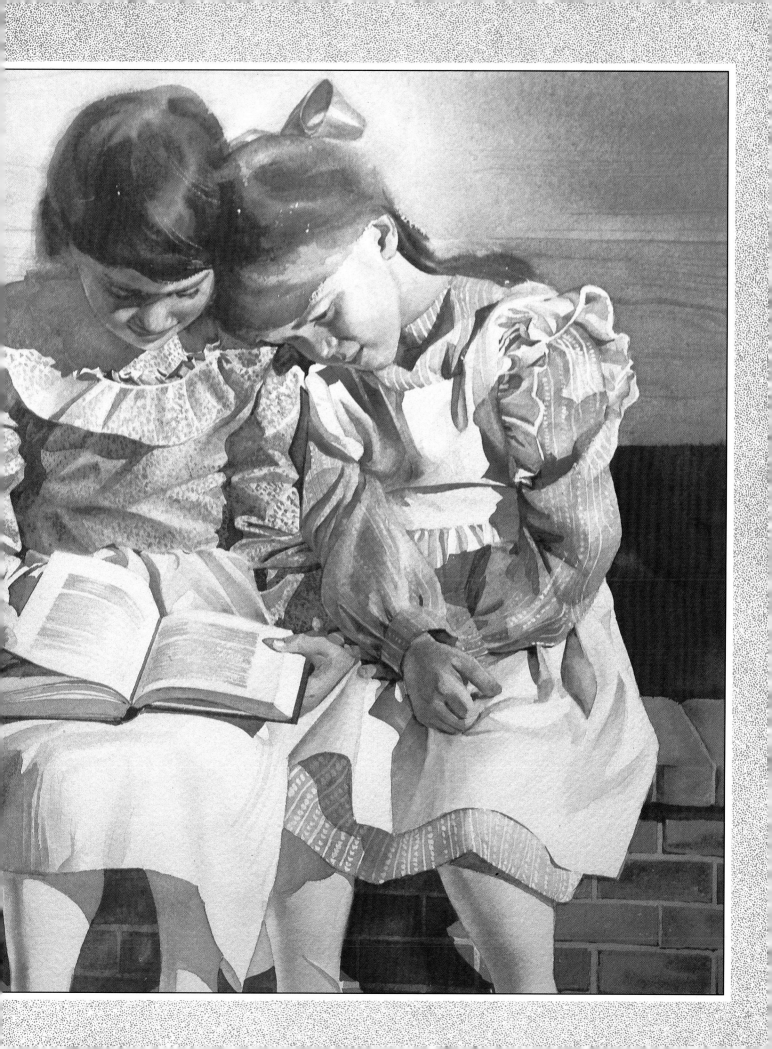

Tools

Over the years I have pared my painting equipment down to the essentials. If you have painted in watercolor for any time at all, you probably have more equipment than you need.

What follows is a list of the materials I use, including two oil brushes I have modified for special needs. These few tools have become comfortable old friends.

I heartily recommend my painting setup to anyone who has not settled on his or her own arrangement. Since I am right-handed, my palette is at my right and my paint rag is situated between it and my watercolor paper. The water, tissue, and paint brushes are all nearby so there's no question of where things are when they're needed. It's been a long time since I've experienced the panic that sets in when I need a tool *fast* and can't find it.

Brushes

A good brush will last a long time and serve you well. Red sable is the best choice, but the initial cost may seem staggering. There are some less expensive brushes on the market that work very well. They include Grumbacher's Rubens series 187 which I have used and found to be an excellent brush. I've been told by my friend who sells art supplies that Liquitex has an excellent brush in their Kolinsky Plus 590 series.

New brushes come with starch in them to prevent damage to the hairs while in the store. Before you buy, ask for a dish of water so you can wash the brush out and see if it holds its shape and resiliency when wet.

If your brush becomes bent or out of shape, rub it gently on a bar of mild soap and when it is thoroughly saturated, use your fingers to model it back into shape. After the brush has dried you can wash out the soap and it'll be as good as ever.

Good brushes are almost essential in watercolor painting, and there are many on the market. The best thing I can say about an inferior brush is that it will wear out quickly.

My brushes include a 1-inch flat and a ½-inch flat Grumbacher Aquarelle for use in background areas. I have three series 7 Winsor & Newton round brushes sizes no. 4, no. 6 and no. 8. The nos. 6 and 8 brushes get the most use in modeling. All that remain are the two Grumbacher Rubens series 187 round brushes. I have a no. 3 for use in small crevice areas, and a no. 10 for large facial areas.

The faces I paint are usually life-size or smaller, and these moderate size brushes are satisfactory for all my needs.

Modified Oil Brushes

In addition to these conventional watercolor brushes, I have modified two oil painter's brushes for special use. As you can see in the drawing at right, I trimmed the end of a flat ½-inch bristle brush to enhance the stiffness, and also sharpened the handle end in my pencil sharpener. I use this pointed end on occasion to draw into wet passages. The resulting dark line is sometimes useful to interrupt a stray hair. The second is a no. 2 synthetic bristle brush. This one is round and I cut the bristles at an angle to form a point. To make these modifications I wedged the bristles between two pieces of heavy paper and used a sharp utility knife for the surgery, cutting through paper and all. This prevented stray bristles from escaping my knife and avoided an uneven edge. These two brushes, used with an acetate frisket to protect the rest of the painting, are used to lift highlights and make corrections.

Palette

Your palette should have a large area for mixing washes, and deep wells to hold the pigments. I much prefer baked enamel palettes to plastic ones. They are easy to keep clean with a wipe of a facial

Here are the two oil painting brushes I modified for lifting highlights and making corrections.

tissue, and they do not stain readily. I use a large Winsor & Newton folding model that is no longer on the market, but there is a smaller version of the same palette available at most art stores. This small version (No. 500) folds and is a nice size to take along when traveling. I also use a 16″ x 11¼″ enameled butcher tray for mixing. These are personal choices, and if you are comfortable with your palette you should use it.

Pencils
You'll need pencils to sketch with and to make the graphite paper needed to transfer your final sketch onto the watercolor paper. For sketching I try to stay away from very hard or very soft pencils. A hard pencil scars the paper, and a soft one makes too thick a line and dirties both your hand and the paper. An ordinary no. 2 is ideal. I use a soft graphite stick or a no. 4B to 6B drawing pencil to make transfer paper, as explained on page 8.

Knife
A razor blade or X-Acto knife is useful to make acetate friskets and to pick small white highlights out of the watercolor paper.

Facial Tissue
I can't paint without facial tissues! I use them to pick up a spill, wipe out a dirty palette, or remove a misplaced color.

Paint Rag
Old bar towels make great paint rags. These are terrycloth towels, about 14 to 16 inches square, that restaurants and bars use to pick up spills. You can usually buy them by the pound at your local laundry after they are too old for commercial use. Flat cloth diapers also make good paint rags. I

bought a dozen for this purpose a few years ago. I keep my paint rags clean by laundering them in the washing machine.

Plastic Credit Card
You will find that a plastic credit card, or better still, a plastic pan scraper is very useful in protecting an "edge" when you're lifting an adjacent color.

Frosted Acetate Frisket
Frosted acetate sheets are translucent, and the frosted surface readily accepts pen or pencil. The acetate should be of sufficient thickness to withstand handling (0.005 or 0.007 is best). To make a frisket, place the acetate sheet over the painting and use a pen or pencil to outline the area where you want the color lifted. Remove the acetate and use an X-Acto knife to cut out the desired shape. Now position the frisket back over the painting and use a moistened stiff brush to remove the offending color. Corrections made in this manner are almost undetectable. It's best to make these corrections at the end, however, because the paper will be distressed and will not accept more pigment well.

Liquid Frisket
Suppose you want to suggest a design or pattern of dots in a dress, as I will in the demonstration painting of Rosemary on page 68. If you do not want to resort to white paint, you need liquid frisket. Liquid frisket is sold at most art stores under several names. Grumbacher's brand is called Miskit. Winsor & Newton calls theirs Art Masking Fluid, and I also have used a brand called Maskoid. Liquid frisket is used to mask areas of work to be protected when applying washes of color. Before you use it, be sure to read the im-

portant instructions regarding the care of your brushes. I don't use liquid frisket often, but it can be very useful at times.

Tracing Paper
You need tracing paper on which to draw your preliminary sketches and outline the facial planes, and also to make transfer paper. I like to use tracing paper that comes in tablet form because it will lie flat. Fourteen inches by seventeen inches is a good size. Tracing paper that comes on a roll is a little more difficult to handle, but it works just as well. When choosing tracing paper be sure it does not tear easily. The transfer paper you make will take a beating, and you want it to last.

Water Supply
One last thing. I use a very large water container. The water stays cleaner longer, and when I spill it, the studio floor gets a good scrubbing!

Use a stiff brush and frosted acetate frisket to make almost undetectable corrections.

Materials

Paper

People who make fine watercolor paper have as much pride in their craft as do fine vintners. Fabriano has been making paper since the early sixteenth century. Today the best papers are still hand (or mold) made, and are 100-percent rag content. Often machine-made paper contains considerable wood pulp and can discolor with age. Inexpensive student grade watercolor paper may be all right for practicing brushstrokes or learning to run a wash. However, I believe beginning painters should start with good quality paper. An unwieldy surface is difficult even after you have mastered the medium.

Most watercolor papers come in three surfaces: hot-press (smooth), cold-press (medium), and rough. Watercolor paper also is available in several thicknesses. The most popular are 140-lb. and 300-lb. A standard sheet measures 22″ x 30″.

I recommend Arches or Fabriano 100-percent rag watercolor paper in either 140-lb. or 300-lb. weights. The 300-lb. paper does not require stretching, so my choice usually depends upon whether or not I want to take the time to stretch the 140-lb. paper.

Stretching Paper

Stretching paper is done to prevent the paper from buckling once the watercolor is applied. The theory is that watercolor paper expands when it's wet. If it's secured to a firm surface when it's in this state, it will shrink as it dries to a tight, flat surface, and will remain flat no matter how much water you pour on it.

There are many theories about stretching watercolor paper. There is a system on the market in which a plywood drawing board is equipped with four clamp sec-

The office stapler and the drawing board are positioned near the sink ready for fast action once the paper is thoroughly soaked.

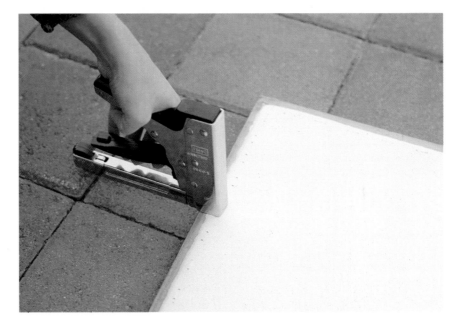

Be careful to keep the body of the stapler and your hand away from the paper as you staple it in place.

tions to hold the paper to the board, and four plug sections that press into the grooves in the clamps to make them tight. Some people use paper tape to secure the wet paper to the board, others use staples, and still others give up on the whole idea of stretching paper and simply use large office-type clips to hold the paper in place. Their theory is that you can move the clips around as the paper dries to keep it flat and workable. This last system works for many accomplished artists; however, for our purpose, I recommend that the watercolor paper be stretched. Painting a portrait requires a great deal of concentration, and I do not want to be concerned with wrinkled paper when it can be so easily avoided.

You may be wondering about the watercolor paper that's been padded and sold as "blocks." This paper has been glued on all four edges, and as soon as you start to paint, it's liable to buckle. For that reason I never use blocks and do not recommend them.

So now you may ask, "How *do* you stretch watercolor paper?" The trick is to have everything ready before you begin, and work fast. First I fill with cool tap water a container large enough to hold the paper. The type of container doesn't matter, just be sure it's clean and free of cleaning compounds—I once ruined some paper by spotting it with tile cleaner. Next, I check my office stapler to be sure it's fully loaded, and place it, along with my drawing board, nearby. The sink I use is too small to hold a 22″ x 30″ flat sheet, so being careful not to crease the paper, I make it into a soft roll. Holding the paper by the edges I submerge it beneath the water. After the paper has soaked for about five minutes it is ready to come out of the water. I then place the

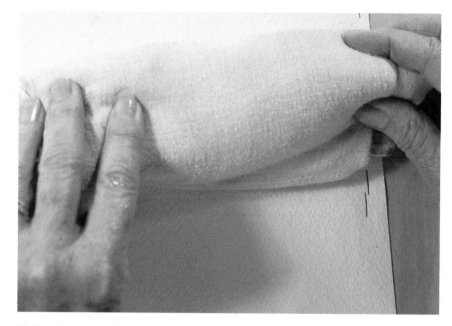

Roll a clean towel or paint rag across the surface of the paper to pick up excess moisture and aid drying.

paper on the drawing board, making sure there are no air pockets between the paper and the board. Working quickly now, I staple around the outer edges, placing the staples about two inches apart. I try to keep my hands and the body of the stapler off the surface of the paper during this operation. Once the paper is securely stapled, I roll a clean towel over the surface to pick up excess moisture. Finally, I lay the board flat to let the paper dry. If the board is tipped, the water will run to one side, and may produce a buckle.

Students have asked me about using previously stretched paper after it has been removed from the board. I have never been able to make this work without the sheet buckling.

Drawing Board
Drawing boards are made of almost everything from plywood to plastic. The plywood boards are usually made of 5⁄16-inch stock and cut to a variety of sizes. The

most popular size is 15½″ x 22½″ because it will accommodate a half sheet (15″ x 22″). The disadvantage of a plywood board is that it is heavy. Some artists varnish the plywood to prevent water from soaking in and warping the surface. If you want to stretch paper on a varnished board, you must use a heavy-duty stapler and resign yourself to breaking the seal.

Some artists use thin Plexiglas or Masonite boards and hold the paper in place with large office clips. The board must be only slightly larger than the paper for the clips to reach and hold. The disadvantage here is, of course, you must work with a paper that has not been stretched.

The boards I like best are made of basswood. They are light, strong, and able to withstand the tremendous pull of a shrinking piece of watercolor paper. My favorite old board is 22″ x 30″ x ¾″ and has served me well for a very long time. Basswood will accept paper tape stretches as well as staples.

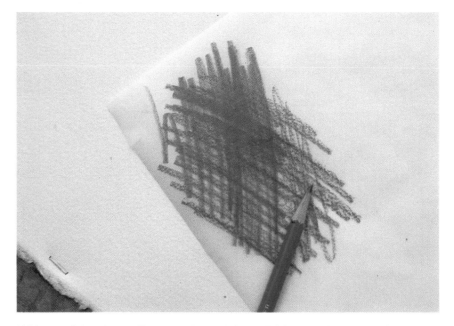

With a soft-lead pencil or graphite stick, scribble lines back and forth in both directions.

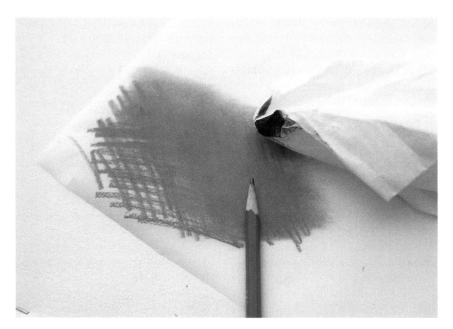

Use a facial tissue to rub the lines together until the paper has a uniformly gray surface.

Transfer Paper

As you will soon see, I make my preliminary sketches on tracing paper, and only after I am satisfied with the drawing do I transfer it to the watercolor paper. Obviously, there remains the problem of *how* to transfer the drawing onto the watercolor paper.

There are commercial graphite papers available, and I'm not familiar with all that are on the market. However, the experience I have had causes me to rely on my own handmade variety. The lines produced by some commercial graphite papers seem to repel the watercolor pigment. Furthermore, these lines are very difficult to erase. With handmade graphite paper you are simply using your own pencil pressed onto the watercolor paper in an indirect way.

Making graphite paper is a rather messy job, but it's easy to clean up afterwards. I like to use a graphite stick or a soft drawing pencil (4B or softer), and good-quality tracing paper. Quality tracing paper is important because it must withstand a great deal of abuse. It should not tear easily, and should be able to bear repeated use.

I usually cut the tracing paper to about eighteen inches square, although any convenient size will do. Then using a graphite stick or the side of a soft-lead drawing pencil, I scribble lines close together, back and forth across the tracing paper, first in one direction and then in another. After the paper is pretty well covered, I use a facial tissue moistened with rubber-cement thinner to rub the lines together until the paper has a more or less uniformly gray surface. The thinner will cause some

streaking, but it helps keep the graphite from dusting off of the paper. Often I run a piece of Scotch tape around the outer edge of the finished graphite paper to further protect it from tearing.

Before you attempt to use your new graphite paper, be sure to remove the excess pencil dust. This is important because if you have not been careful to blow, shake, or brush off the excess graphite, it may leave black dust on your watercolor paper. Your desk and hands can get pretty grubby during this process, but soap and water will clean things up in no time.

To use graphite paper, just tape the final drawing into position on the watercolor paper, slide in the graphite paper, graphite side down, and trace the drawing. I like to use a red ballpoint pen to trace over my original drawing—it's easier to see where I have been.

Another way to transfer your drawing is to hold it to the light—a windowpane will do—and use a soft-lead pencil to retrace your drawing on the back side. This eliminates a great deal of mess, but in my experience, does not make as clear a copy, and if you intend to transfer many drawings, this method may prove to be more work in the long run.

Paint
Today, paintings are often called watercolors if they are painted with any water-based paint, including acrylics, tempera and gouache, as well as transparent watercolor. In this book we will use only transparent watercolor. These pigments come in tubes and in blocks and are usually labeled "artists' water colors" or "water colors artists' quality." I

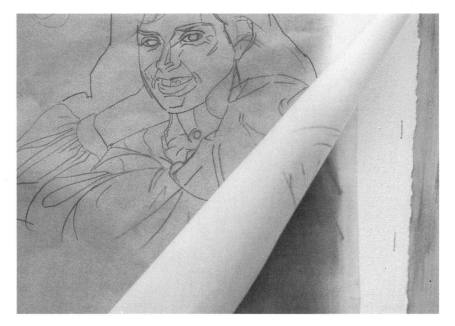

Tape the final drawing into position on the watercolor paper, slide in the graphite paper and trace the drawing.

prefer paint in tubes because the soft consistency makes it easy to pick up the paint on a brush.

There are several good brands on the market. I am familiar with Grumbacher, Winsor & Newton, and Liquitex. I have found that, between brands, some colors may vary. For instance, Liquitex and Winsor & Newton have a clear Payne's gray, while Grumbacher's color has a more chalky appearance and is somewhat more opaque. I also much prefer Winsor & Newton's burnt sienna to either of the other brands—the color is brighter and more transparent.

I use Winsor & Newton paint. I mention this because if you use the colors I suggest, and they appear to be different, it may just be due to the difference between brands of paint.

The following are the pigments I keep on my palette all the time. There are several other colors I

use occasionally and I keep them fresh in my paint box until they are needed.

new gamboge	sap green
raw sienna	Winsor or Thalo green
cadmium orange	cerulean blue
burnt sienna	cobalt blue
burnt umber	ultramarine blue
cadmium red	Winsor or Thalo blue
alizarin crimson	
Winsor red	

The colors are arranged with the warm colors on one side and the cool ones on the other. This arrangement forces me to reach across the palette to pick up a complementary color. You'll see why this is useful when we begin to mix sparkling dark colors. I want to emphasize the importance of knowing where each color is located on your palette. You don't want to have to stop and look around for a color when you need it.

1.

The Basic Head

Jan Kunz ©'87

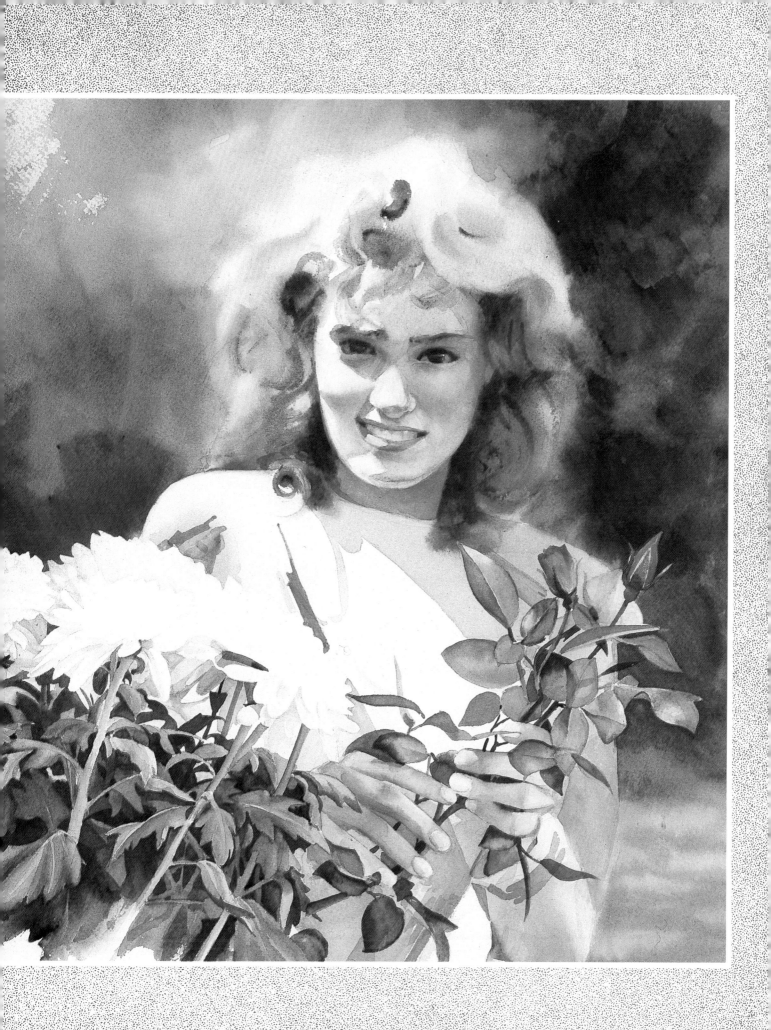

Drawing: The First Step

When I first started drawing people, I would always begin with my subject's left eye. That turned out to be a lot like drawing a pair of trousers by starting with the belt loops! It was obvious I had to find another way. Anatomy books did not prove very helpful, even though I learned impressive terms like "temporal" and "zygomatic arch." It wasn't until I met the humble egg that things began to go right. I discovered what many artists before me have known. The head is shaped very much like an egg, and by applying certain simple measurements to this ovoid shape, it's possible to properly locate the position of all the human features. Of course, you will find people with long noses or small ears. However, these adjustments can easily be made once you have located their approximate positions. The system works! From now on, you will find that every head in this book is developed from a basic egg-like shape.

As you study this section it's a good practice to make sketches as shown in the illustrations. Draw the ovals and measure where the features are located. This will help you remember these important relationships. The truth is, you learn to draw and paint people by drawing and painting people.

As you venture into portraiture, remember there is no such thing as an inanimate head. Heads show emotion. They weep, laugh, or show anger. They are fat, thin, or even ordinary. Every head must communicate some sort of emotion, or create a reaction in you. The viewer must feel he is seeing the portrait of someone who is now, or has been, very much alive.

(right) "Soap and Luv" 14 x 20

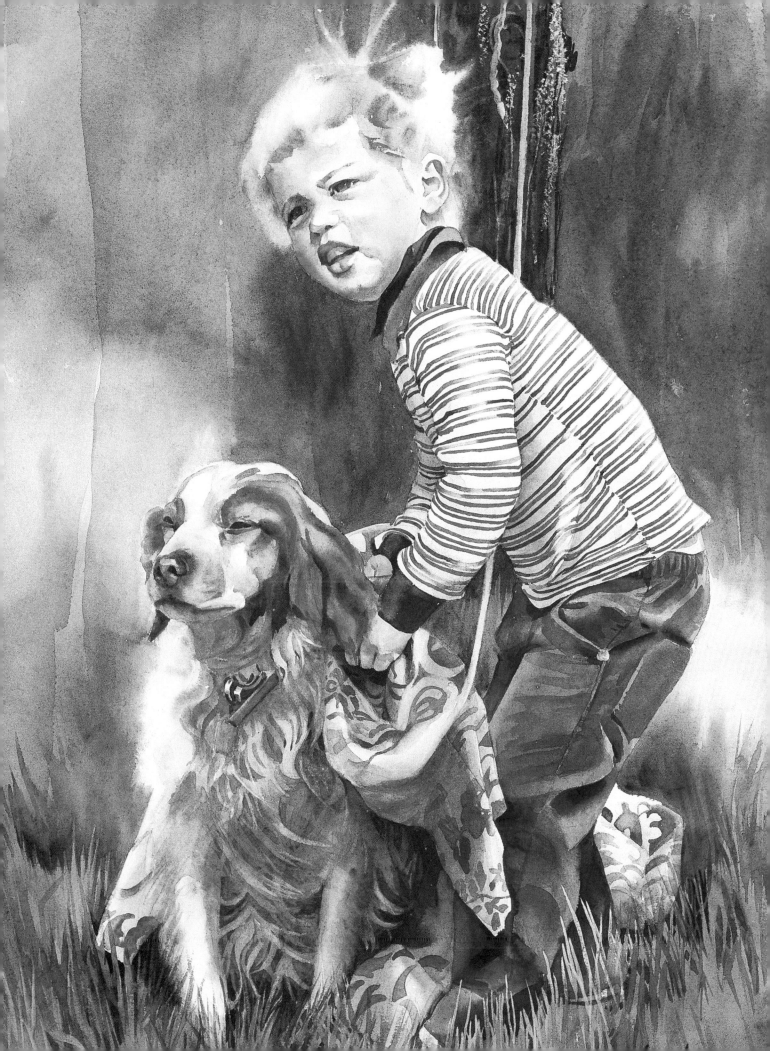

The Structure of the Head

The skull has an ovoid or egg-like shape. Viewed from the side, you can see the major axis is tilted. The form widens at the top, and presents a more or less vertical face. Notice how the skull fits into this simple shape, which helps us see the underlying structure beneath the visible features. The skull on the left has a vertical line drawn down its center. This line helps balance the features when drawing a head-on view.

The eyes are located halfway between the top of the head and the bottom of the chin. Viewing them from the side you can see they are located *back* from the surface of the ovoid in the bony eye socket.

The eyebrows are placed a little above the eyes on (or near) the brow bone. The bottom of the nose is located halfway from the brow line to the bottom of the chin. These same measurements are used to place the nose on the side view. The nose projects in front of the facial oval.

The ears are located *behind* the vertical line drawn halfway between the face and the back of the head and extend from the brow line to the bottom of the nose. Notice that the neck is attached to the head at an *angle*.

All that's left is to place the mouth, which is located about one-third the distance from the bottom of the nose to the bottom of the chin.

Remember these simple relationships and you have the fundamental information you need to draw portraits.

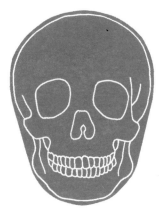

From a straight-on view, the skull fits into an egg-like shape.

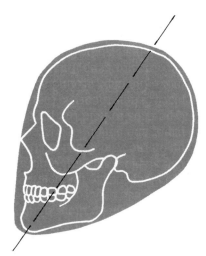

Viewed from the side, the ovoid shape of the head widens at the top and the major axis is tilted.

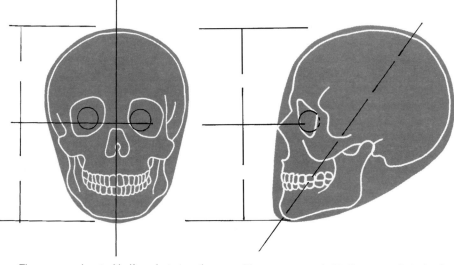

The eyes are located halfway between the top of the head and the bottom of the chin.

The eyes are nested in the eye sockets, back from the surface of the face.

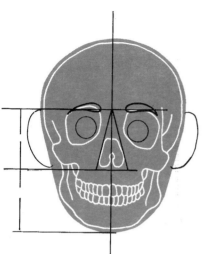

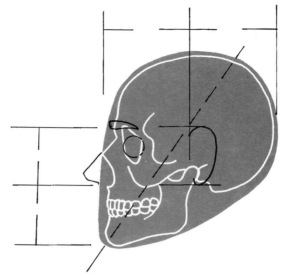

The bottom of the nose is halfway between the eyebrows and the chin. The ears fit between the lines locating the eyebrows and the bottom of the nose.

The ears are located behind a vertical line drawn halfway between the front and back of the skull.

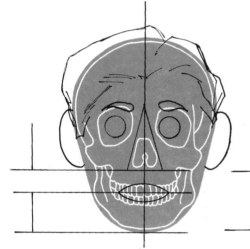

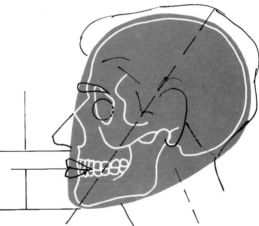

The mouth is one-third the distance from the bottom of the nose to the chin.

In this profile view, the same measurements are used to locate the features as in the front view.

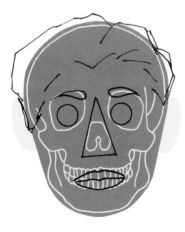

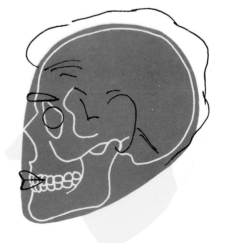

This facial diagram shows the location of the features.

This side view of the facial diagram shows the location of the features in profile.

Blocking In the Head

Here are a few of the drawings that went to make these water-colors of my friend Tracy. These sketches help you see how I used the relative measurements described on the previous page to draw this head. The basic ovals were done on tracing paper, as were the rest of the drawings. I superimposed a series of tracing paper overlays to develop the drawings to the next stage, and so on through each stage to the final drawings.

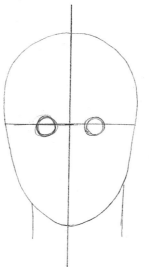

Here is the basic oval shape of the head. The vertical line helps in balancing the features. The eyes are spotted about one-eye-width apart and approximately halfway between the top of the head and the chin.

Next the brows are placed a bit above the eyes, and the bottom of the nose is located halfway between them and the bottom of the chin. The mouth can now be put in its place, one-third the way down from the bottom of the nose to the chin.

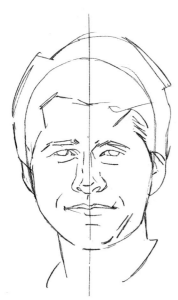

After the basic head is drawn and the features are located in their proper positions, it's time to begin to modify the face to become that of your model.

Even though realistic features, color, and modeling have been added, the underlying construction of the head is still visible.

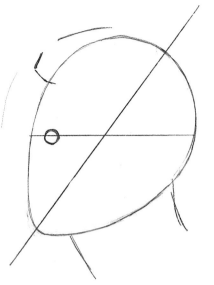

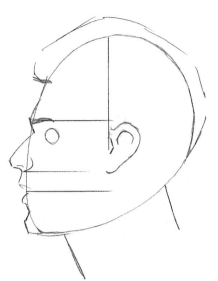

Viewed from the side, the ovoid form is larger at the top, and the axis of the head is tilted, presenting a more or less vertical front. The eyes are drawn back from the front of the face.

The features are located the same as they were in the front view; however, notice the ear is placed on a line drawn halfway between the front and back of the skull.

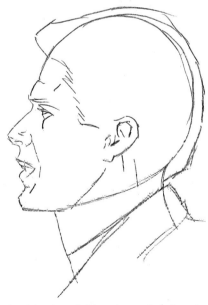

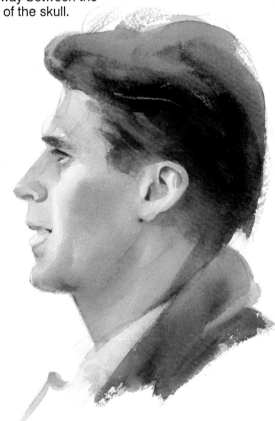

In this sketch I begin to develop the features, define the jawline, and locate the hairline at the temples.

In this profile view you can see once more the basic construction that went into drawing this head. No amount of fancy brushwork can compensate for a head that is poorly drawn. However, by learning these simple relative measurements, even beginners will soon find themselves drawing convincing heads.

Heads in Various Positions

On the previous pages, you've seen how to draw the head and locate the features when you're drawing a full face or profile. However, in portraiture, the head is seldom seen in these "straight-on" views. Heads are usually slightly turned, leaning to one side, or tilted up or down. To help you see what happens to the guidelines when you view the head from various angles, I have transferred these lines to the shell of an egg. As you can see, they become elliptical, or curved, as they run around the surface of the egg. Using a hard boiled egg (on which you have sketched these guidelines) as a model is an excellent way to learn how to draw a head in any position.

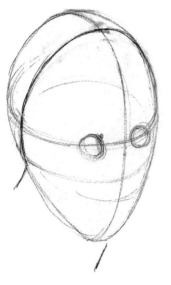

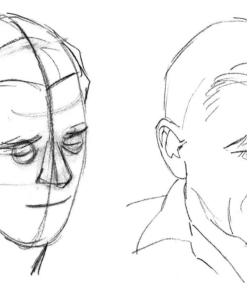

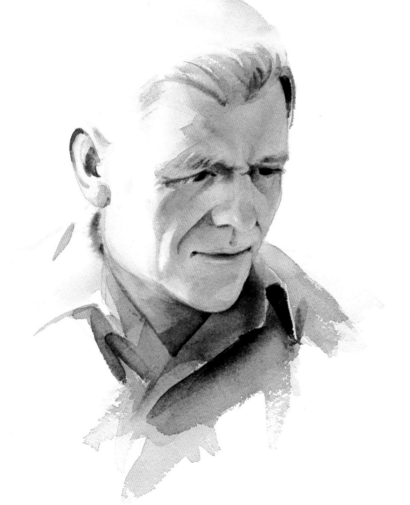

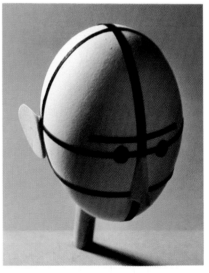

Viewed from above, the measuring guidelines appear elliptical. Notice how the brow overhangs the eyes and partially obscures them. In this position the nose and forehead appear longer than from a straight-on view.

18

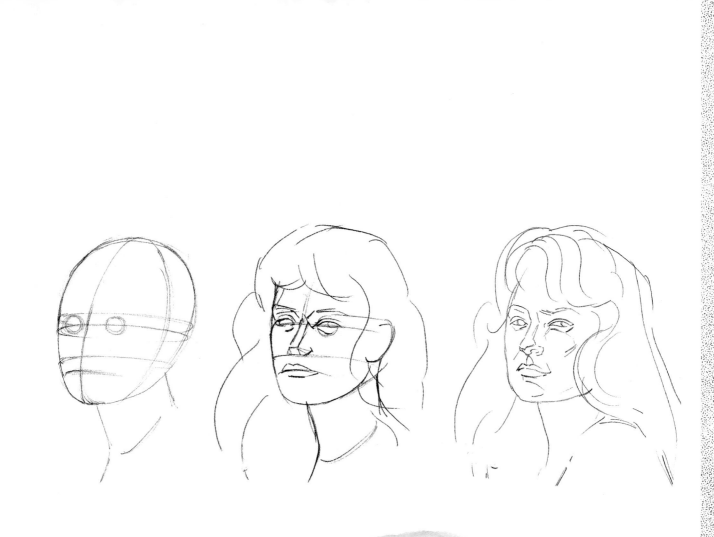

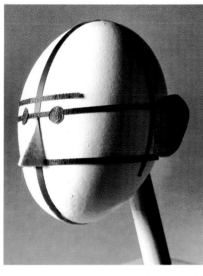

Here the view is nearly at eye level. The curving surface of the ovoid makes her right eye appear noticeably smaller than her left. The eye and mouth on the sketch are modified to reflect this roundness.

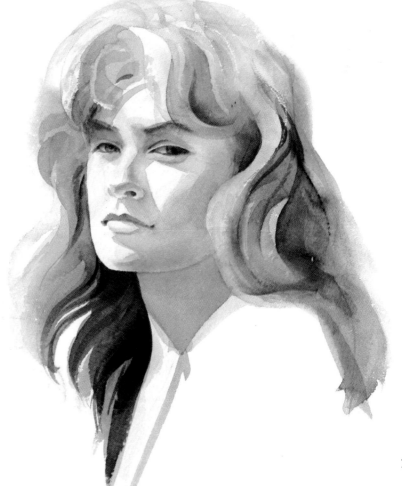

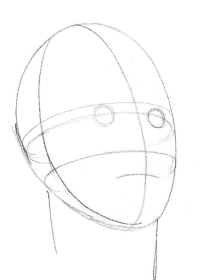
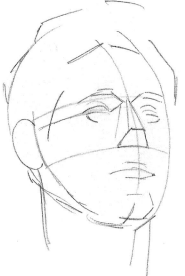
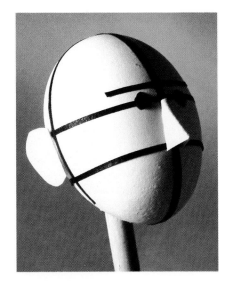

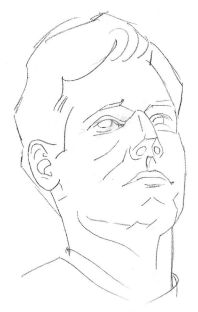

This ovoid is tilted back and our view is from beneath. Here the measuring guidelines are slightly elliptical to reflect this position. From this view the eyes are noticeably set back from the surface of the ovoid.

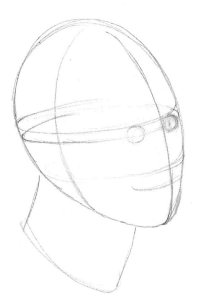
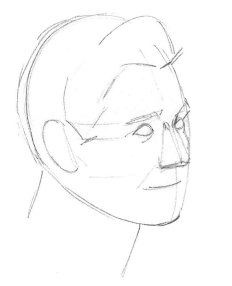
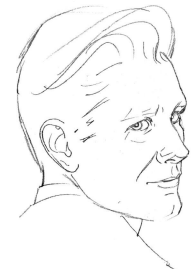

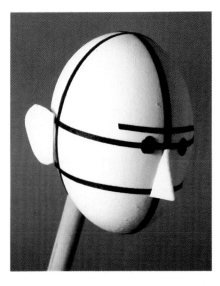

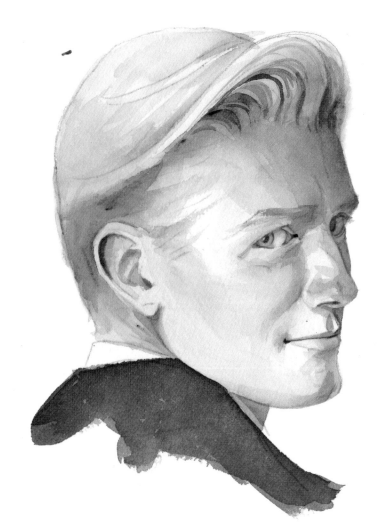

In this view we can see that his left eye is partially obscured by his nose, and one side of his mouth is barely visible. Studying measuring lines drawn on the surface of an egg can increase your awareness of the relative positions of the features, no matter from which position you view your model's face.

Features

While every face has two eyes, two ears, a nose, a chin, and a mouth, no two faces are exactly alike. Therefore, every face requires careful observation.

In this section we will look at the construction of the features and make a simple analysis of them. Many times it's far better to suggest a feature rather than to draw or paint every detail. Once you understand the construction, you can convincingly omit detail and the effect will carry. But first, you must understand everything that you omit.

Eyes

It has been said "The eyes are the windows to the soul." They are certainly the most expressive feature of the face. A single glance can reveal excitement, joy, or longing.

The eye is well protected by the bony structure that surrounds it. Not only is it set deep in the eye socket, it is further protected by the frontal bone of the forehead above, the inner side of the nose, and the cheek bone below. These are important things to remember when you place the eye.

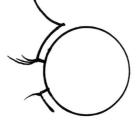

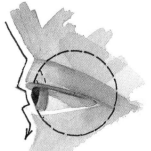

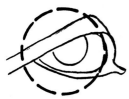
The artist must always think of the eyeball as a sphere.

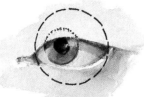
The upper lid slides up and down over the eyeball. The lower lid moves very little.

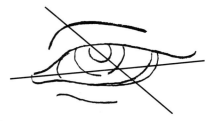
The arrow shows how the forms go in and out. The upper lid is somewhat thicker than the lower lid.

In a three-quarter view, the eye appears nearly almond shaped. Remember to sketch the lid so it seems to curve around the eyeball.

Even though you show very little of the eyeball, the part you do see must give the impression of roundness.

The high point of the upper lid is toward the nose. The low point of the lower lid is away from the nose. Notice that the lower lid joins the upper lid at almost a right angle at the outer corner.

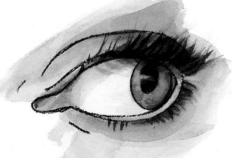

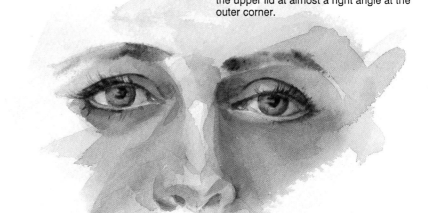

The lids are separated by a pink membrane at the inner corner of the eye. At the outer corner the lids come together and the upper lid hangs slightly over the lower one.

The eye is always moist and reflects any light that strikes it. The location of the highlight is determined by the direction from which the light is coming. This highlight is an important detail and should be placed with care.

The eyes are protected by the surrounding facial bones. The eyebrows and lashes offer still further protection, with the upper lashes being much thicker and longer than the lower ones.

Depending upon the individual, the eyes are located about one eye-width apart.

Nose

We don't usually think of the nose as expressing emotion, but who among us has not "turned our nose up" at something distasteful.

A nose can give character to a face. We think of a large nose as being Roman or aquiline. The witch in a fairy tale may have a hooked nose. A flat or broken nose might be associated with a boxer.

The nose has a long wedge-shaped form. It's attached to the forehead with another smaller wedge shape. Where these wedges meet, the nose is usually thin, and it becomes wider at the bottom. The upper section is made of bone and the bottom is made of cartilage. This cartilage is flexible and responds to the pull of the facial muscles. These muscles can cause the nostrils to twist or dilate in anger, as well as in a smile.

The nose gives character to the face. Children's noses are shorter and softer in appearance than adults'. The rounded cheeks and smoothness between the eyebrows suggests this to be the nose of a young person.

The tip of the nose usually slants upward, while the nostrils slant down.

There is a step down from the brow to the narrowest part of the nose, right between the eyes. The side of the nose is also the steepest at this point.

Viewed from beneath, the nostrils slant toward one another at the tip.

Think of the nose as a long wedge-shaped form attached to the forehead with a small wedge-shaped form.

The bottom of the nose is composed of five pieces of cartilage. Two form the nostrils, with a third separating them, and another two form the tip. This part of the nose continues to grow and change shape with age. The upper part is bone and is responsible for the nose's basic shape.

23

Mouth

Of all the features, the mouth is the most flexible. With every word and emotion the mouth can change its size and shape.

The upper and lower lips vary greatly in appearance. The upper lip is longer and thinner, while the lower lip is fuller. The upper lip can be thought of as having three sections, while the bottom has only two. Viewed from the side, the upper lip projects over the lower one, and there is a slight depression where the lips and cheeks meet.

The general shape of the mouth is greatly influenced by the dental arch beneath the lips. In your drawing remember that the mouth should always reflect this curve of the teeth. If you see a person who has lost his teeth you are bound to notice the mouth is sunken and loose, and less of the lips are visible.

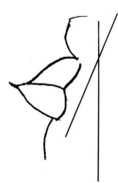

In a profile view, the upper lip usually projects above the lower one.

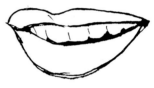

It's convenient to think of the upper lip as divided into three sections, and the bottom into two. The center portion of the upper lip is directly under the nose, as is the centerline of the lower lip.

The high points on the upper lip are near center; the low points of the lower lip are farther to the sides.

A smile or laugh shows the upper teeth. As the corners of the mouth are pulled back they form a small depression or hollow where they meet the cheeks.

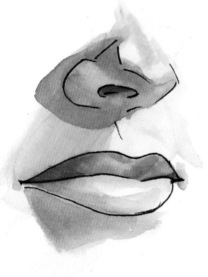

The upper lip is flatter and more angular than the bottom lip, which is fuller and rounder.

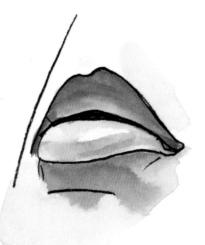

There is a slight furrow under the bottom lip. This indentation is usually more noticeable in men than in women.

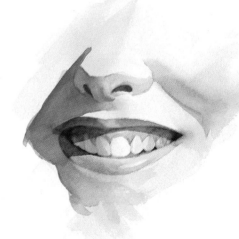

The shape of the mouth and lips are influenced by the curve of the dental arch. The entire mouth should reflect this "roundness."

Ears

Ears not only vary greatly in size between individuals, but some project from the side of the head, while others lie almost flat. The ear has a fleshy lobe at the bottom, but the rest is mostly made of cartilage. The curves and whorls of the center bowl section is where most differences occur.

As we have seen, the top of the ear is on a line with the eyebrow, and the bottom is on a line with the base of the nose. Viewed from the front, the ears slant in at the bottom, parallel to the sides of the head. It is when the head is turned at an angle that drawing problems may arise. Remember the ear is located behind an imaginary line halfway between the front and back of the head.

The ear is somewhat saucer-shaped. The center section resembles a bowl.

When viewed from the back, the outside of the "bowl" is visible, and the ears tend to run parallel to the sloping plane of the head.

The outside rim of the ear is curved to act as a scoop for sound waves.

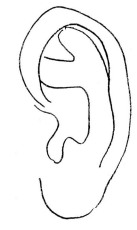

The flap that protects the ear canal opening catches light and contrasts with the shadowed recesses of the ear.

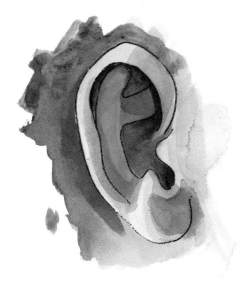

Ears vary greatly between individuals. Most of the differences occur on the whorls of cartilage that make up the outer ear.

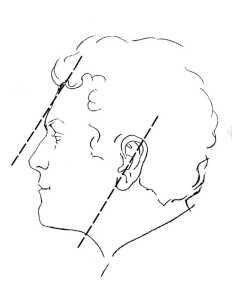

The ear slants the same as the nose. The ear is located *behind* an imaginary line located halfway between the front and the back of the skull.

Remember that your model's ears are uniquely his own, and therefore must be drawn with the same care you give to the rest of his features.

25

Dos and Don'ts

Pictured here are three common drawing errors that sometimes occur when the head is positioned at an angle. Many errors can be avoided by referring to the basic head drawing and checking measurements while you are still in the planning stage.

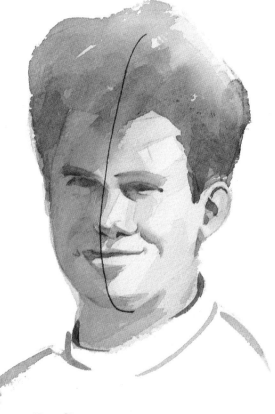

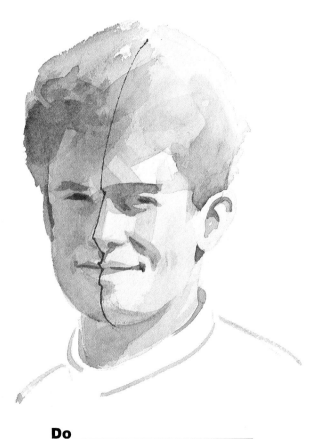

Don't

locate the tip of the nose behind the centerline when the subject is viewed from an angle.

Do

let the centerline of the face follow the features.

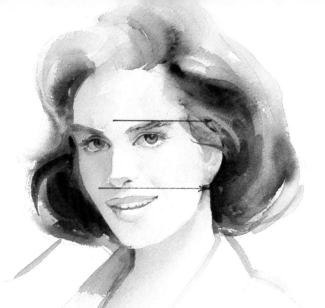

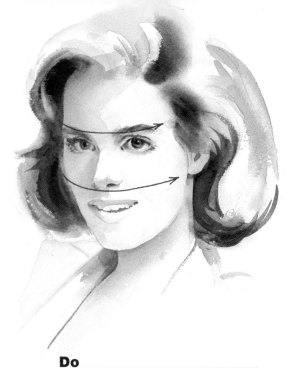

Don't

use straight horizontal lines when drawing the head at an angle. This can result in distorted and misplaced features.

Do

draw the guidelines around the egg shape.

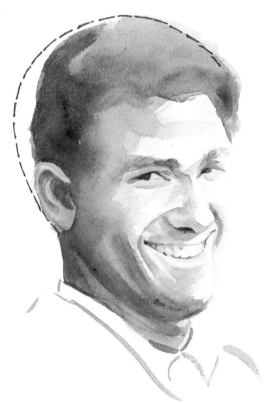

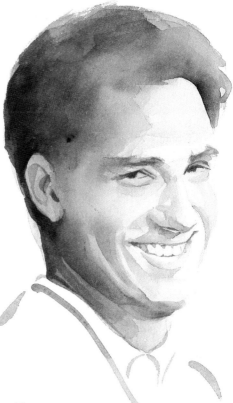

Don't

flatten the top or back of the head, making the face too large for the skull.

Do

remember that the top of the head appears wider when viewed from an angle. Check the measurements to be sure you leave plenty of room for the skull and hair.

Using Tracing Paper

Making your initial drawing on tracing paper rather than on watercolor paper may at first seem to be a waste of time, but it does have worthwhile advantages.

Edgar Whitney, a watercolorist I greatly respect, said, "A watercolor portrait, labored over making many changes to achieve a likeness, will not be a fine watercolor and, therefore, not a fine watercolor portrait." This is a fair assessment. It's far better to make adjustments on drawing paper before you begin to paint. When the drawing is finally transferred to the watercolor paper, the only task remaining is to paint a fresh, spontaneous-looking portrait.

With this admonition in mind, this is how I use tracing paper in preparation to paint a watercolor portrait. After carefully observing the model, I first draw the basic shape of the head. I hold the pencil well back from the point and let my arm swing freely, making several ovals until I am satisfied with the result. Then I place a center line from the top of the oval to the bottom corresponding to the center line of the model's face. This line helps me balance the features. If I am viewing my model from an angle, the measurement lines must be curved *around* the oval shape to suggest a three-dimensional form. Next I draw the features in their proper location. By now the drawing may be a little confusing, so I use a clean tracing paper overlay in order to re-draw just the oval I want from those I see underneath. Now I can draw the modified features in their correct location. I use as many tracing paper overlays as I need, each time refining the drawing, keeping what I choose, and discarding the rest. Only after the sketch is finished to my complete satisfaction do I transfer it to the watercolor paper.

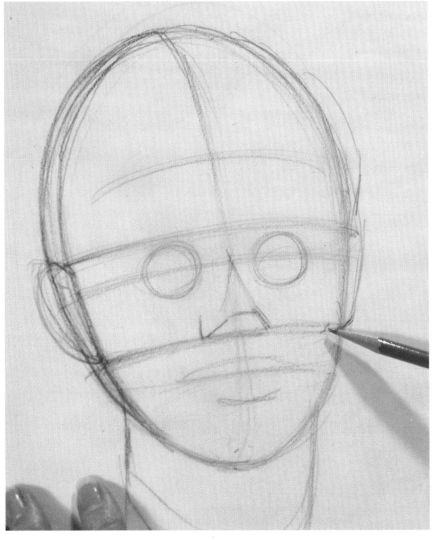

The freely drawn oval approximates the position of the head and the measuring lines locate the features. Position the features and select the outline of the head.

28

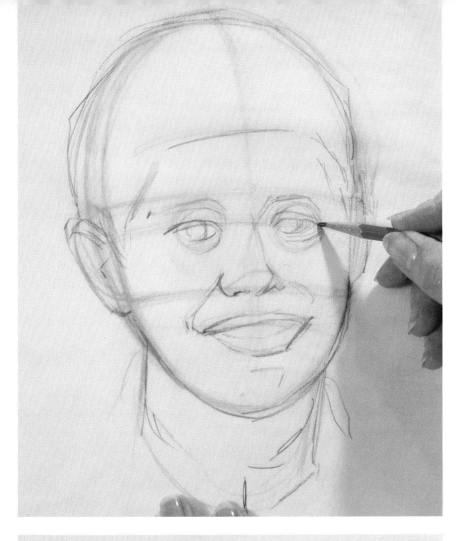

Refine the features either directly on the same overlay or on a fresh overlay of tracing paper.

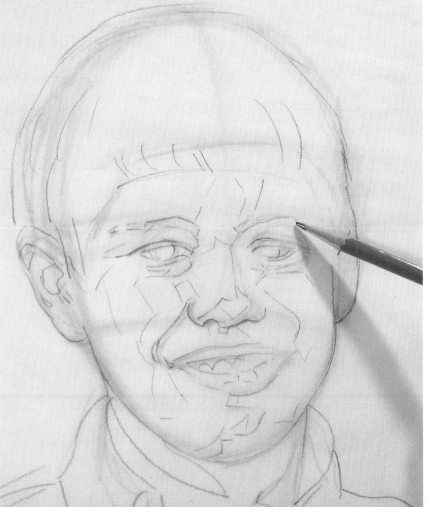

Modify the features to resemble the model, continuing on the same overlay or on another fresh piece of tracing paper. Study the facial planes and make any notations that will aid in the final painting process.

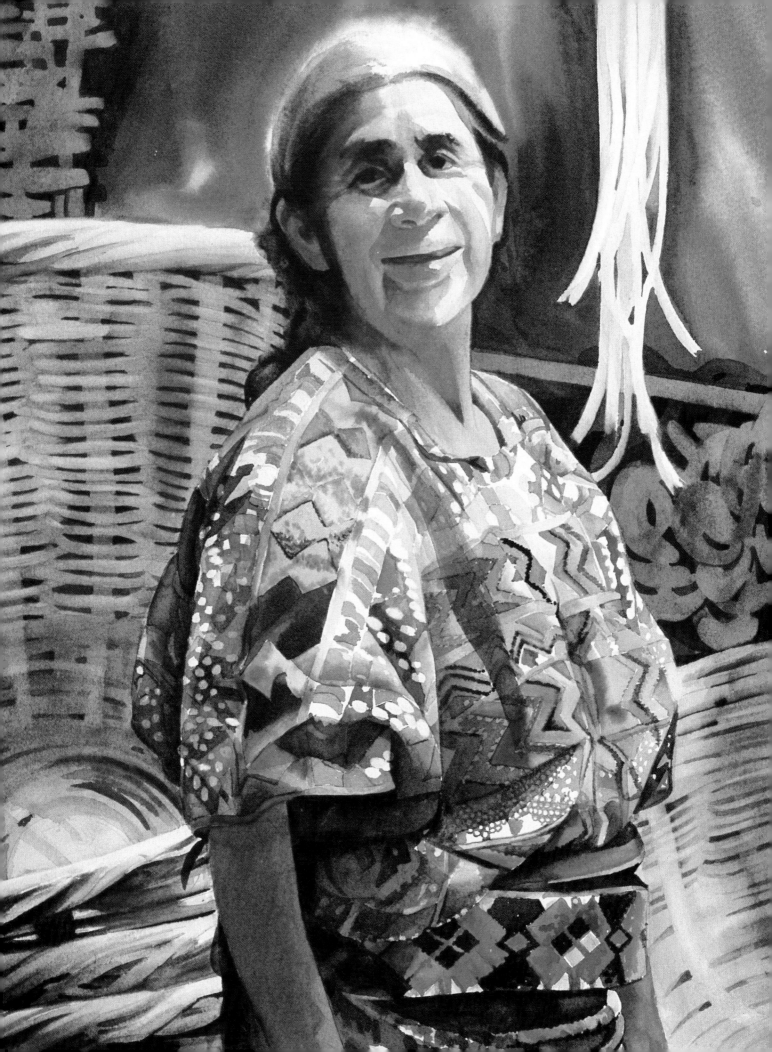

The Illusion of Three-Dimensional Form

Before we can start thinking about painting a beautiful smile or expressive eyes, we must consider the fundamental goal of creating the illusion of a three-dimensional, solid form on a two-dimensional surface. To do that, it helps to know that our eyes really see three things: *shapes, values,* and *edges.*

Everything has a shape. The most simple shapes are silhouettes of whole objects, like a duck or a tea cup. We could identify these objects if they were only black paper cutouts.

Every shape has a value. Value means the lightness or darkness of an object. For instance, my old iron skillet is black, and the new one is shiny aluminum. They are shaped the same, but you would have no difficulty telling them apart when you observed their respective values.

Edges are the borders we see between two shapes. They are either soft and fuzzy, or sharp and hard. The edges between the light and shadow planes of a cube are hard, while those on an egg are soft.

Of these three (shapes, values and edges), *shapes* are by far the most important. The shape is our eye's interpretation of the three-dimensional quality of the object. Values and edges further describe these shapes. We can identify a rhinoceros by its shape. The value tells us if it's a white specimen.

The combination of hard and soft *edges* in a drawing also help to create the illusion of reality. We must recognize these edges and use them along with shapes and values in our paintings to accurately reproduce the things we see.

(left) "Basket Woman" 15 x 22

One Source of Light

Simplified light and shadow areas create the strongest illusion of solid form. In order to keep the shape of the shadow simple and readable, there must be only one source of light. With one source of light you can easily see two main values: a light-struck area and a shadow area. Of course there will be some variation of value within each area. There may be reflected light in the shadow side, or the light-struck side may have surfaces that appear darker because they are turned slightly away from the source of light. But remember, it's the simple separation of light and shadow that describe the object. Try to avoid complicated lighting effects. Many students have tried, unsuccessfully, to paint a portrait from a photograph taken by a studio photographer. The main stumbling block is that multiple lighting obscures facial structure, and the basic shadow form is lost.

The overall shape is the key to recognizing the identity of an object. Almost as easy to recognize as the overall shape is the shape-within-a-shape. The pictures of the man illustrate that it's the simplified shape of the light and shadow areas that creates the illusion of a real figure.

Simple shadow forms become the basis for a portrait. With one light source you can see two main values: a light-struck area and a shadow area.

The 40 Percent Rule

Landscape painters have long observed that the shadow sides of objects in sunlight are a full 40-percent darker than the sunlit side, and all things being equal, their cast shadows are somewhat darker still. Practical experience, along with careful observation, have led me to believe that this relationship is a basic fact of nature.

This information provides an important key to unlocking the door to color and "glow" in watercolor. You see, by using this 40 percent value difference between the light and shadow sides, your model will appear as if he or she is bathed in sunlight. Later, you will see how to use reflected light along with the 40 percent rule to add glow to your watercolors. By making a distinct contrast between sunlit and shadowed areas, and by using pure, rich color in those shadows, you can achieve a radiant liveliness in your portraits. But for now, understanding the 40 percent relationship provides the simple answer to the question, "How dark should the shadow be?" You know the answer—40-percent darker than the sunlit side!

Value Scale

It's obvious that we need some means of measurement in order to arrive at the correct values in our paintings. This process isn't as difficult as you might expect. The fact is that the average human eye sees about eleven distinct variations in value. Since our watercolor paper is not pure white, we can construct a value scale, or chart, with off-white (the value of our paper) at 1 and black at value 10. Then it only remains to count up or down 4 values, or 40 percent, to arrive at a near correct value.

At first, getting the correct value relationships is more important to the success of your painting than getting the right colors. If your value relationships are correct, your painting will be better than if your colors are correct and your value relationships wrong. Develop the habit of considering the values you want to use in your portrait before you think about color.

Many artists often overlook the importance of value because they are distracted by the more obvious appeal of color. As a consequence, their paintings lack an exciting underlying pattern of lights and darks.

Here is a value scale similar to the one I use. I hope I can persuade you to use one from now on and check the value relationships as we continue. I consider my value scale almost as important as my brushes.

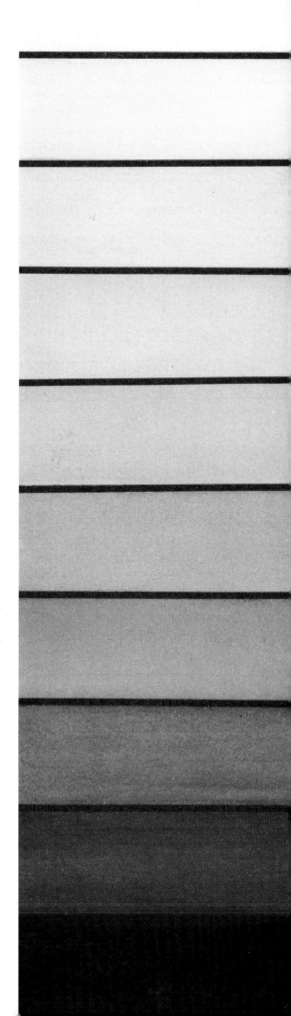

The 40 Percent Rule at Work

Applying the 40 percent rule should become an automatic response when you're thinking about how dark to make the shadows in your portraits. If the light-shadow relationship is not correct, your portrait will have neither a convincing illusion of three dimensions nor a good design based on strong, simple lights and darks. Examine the photographs on these pages to see the 40 percent rule at work. Notice that there's a variety of subjects and lighting conditions, but there is a consistent 40-percent difference between areas in sun and areas in shadow. Also notice that the shadow cast by an object is a bit darker than the shadow area on the object itself.

The shadow areas are not merely dark, uninteresting shapes which offset the bright areas in sun. Instead, shadow areas are often filled with color. Although these colors are subtle and often impossible to photograph, seeing and painting the colors in shadows is a very important part of the *glow* that makes a portrait successful.

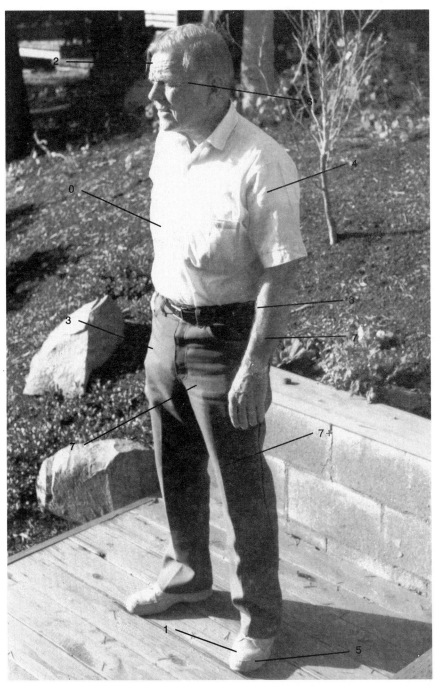

Here you can see the consistent value relationships between the sunny and shadow sides of the man photographed standing on the deck. His white shirt is value 4 in the shade; his shoes, which I see at value 1, appear at value 5 on the shadow side. Notice that the cast shadow is slightly darker than value 6, as you might expect, since cast shadows are somewhat darker than 40 percent.

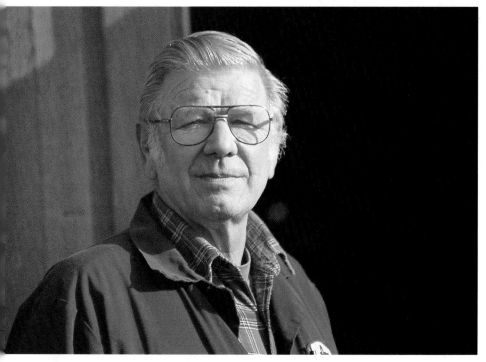

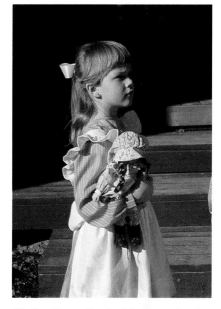

The shadow side of this man's face is clearly 40-percent darker than the sunny side. Notice the warm reflected light on his neck. That beautiful red is bouncing off of his shirt color. Can you see the cooler areas on his face and shoulders?

Notice the reflected light under the girl's sleeve, and on the apron below. The shadow side is 40-percent darker than the sunny side, and the cast shadow is somewhat darker still.

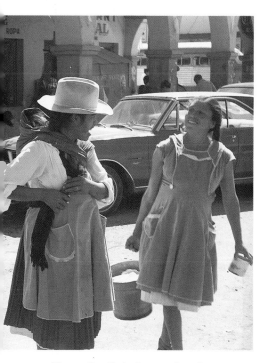

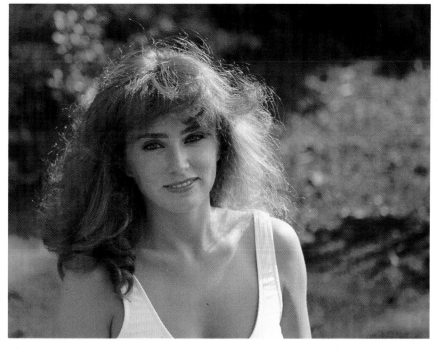

Here, the light is coming from above and behind the central figures. You can see the great amount of color on the shadow side. The shadow side of the hat is flooded with reflected light, and the glow beneath the brim is unmistakable.

The soft edges of this model's hair seem to sparkle in the sunlight. The shadow side is obviously 40-percent darker than the sunlit area, and it's flecked with light from behind. The top of her hair takes on a cooler hue. Can you see how much warmer the vertical side of her arm appears than the top of her shoulder?

Demonstration
An Indian Youth

This step-by-step demonstration and the one that follows are done in values of gray because I want to show you the importance of value relationships in interpreting sunlight.

Some of the drawings and paintings have value numbers assigned to them so you see that the value relationships are consistent throughout the painting process. The pigment I used in painting these demonstrations is Payne's gray.

Somewhere I heard that if it were possible to take all the aspects of color, which are hue, value, and intensity, and encase them into a 36-inch ruler, *value* is so important it would require 32 inches of space. I do not doubt that assessment.

If you paint along with me, remember that watercolor pigments dry lighter than they appear when wet, so you may want to try your paint on a separate piece of paper and let it dry to check the value before painting.

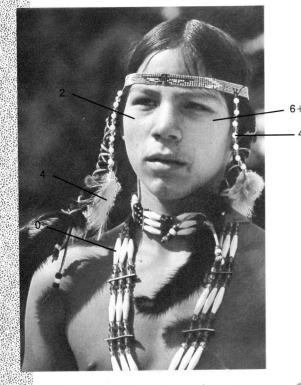

This Indian youth was photographed at a powwow in Siletz, Oregon. If you compare values between the sunny and shadow side of his face you'll see again the 4 value, or 40 percent, relationship.

It's important to be accurate when painting this young man's costume because it may serve to identify his tribe. Costumes are often passed from father to son, so it's important to respect the heritage the costume represents.

This diagram reproduces the shadow form you'll be able to see by squinting your eyes to eliminate as much light as possible. As you perceive more light, you'll be able to distinguish the facial planes I have outlined. These planes are visible on the shadow side as well as in direct light, and they serve to modify and further describe the face.

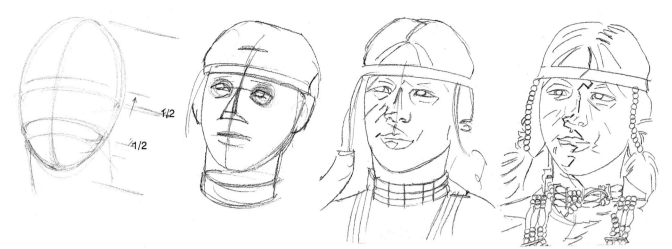

Here is the drawing in progress. I include enough detail to ensure that my total attention can be directed exclusively to the painting. The shadow side is emphasized so you can see how it conforms to the diagram.

2

2

Step 1

After tracing the head onto the watercolor paper, I paint the skin tone freely onto the face, neck, and shoulders. Notice I made no attempt to paint around the eyes. The value of this first wash is 2. I inadvertently let this light value of Payne's gray cover the string of beads at the left side of his face. This mistake doesn't concern me because these beads are white, and I know that white in shadow is value 4, so I need only darken their value to correct my error.

Step 2

After the first wash is dry, I prepare a puddle of pigment that's 4 values darker than the sunny side of the face (value 2) and paint the shadow areas (value 6). The shapes of these shadows identify the subject, so I take care to place them accurately. I pay special attention to the *edges*, always trying to keep the rounded surfaces soft.

All the beads in shadow are painted to value 4. To paint the white feathers in shadow, I first moisten the paper, in the area of the feathers, somewhat larger than I want them to appear. Then I drop pigment into the center of this moistened area at the place where the beads and feathers are joined. The pigment will flow into the pre-moistened area and create a soft edge.

A word of caution. Try the above procedure on a separate piece of paper if you're new to watercolor. You must use just a bit of pigment somewhat darker than value 4. The water on the paper will lighten the value. Too much water or pigment can result in the pigment flowing across the entire pre-moistened area and creating a dark, hard-edged blob. With watercolor it's possible, once the passage is thoroughly dry, to carefully re-wet the paper with clear water and add pigment wherever you wish and not disturb any previously painted passage.

Step 3

After the shadow wash is thoroughly dry it's time to model the sunlit side of the face. I like to think of my brush as a sculptor's tool gently carving the rounded surface into facial planes. Each stroke further models and refines the face.

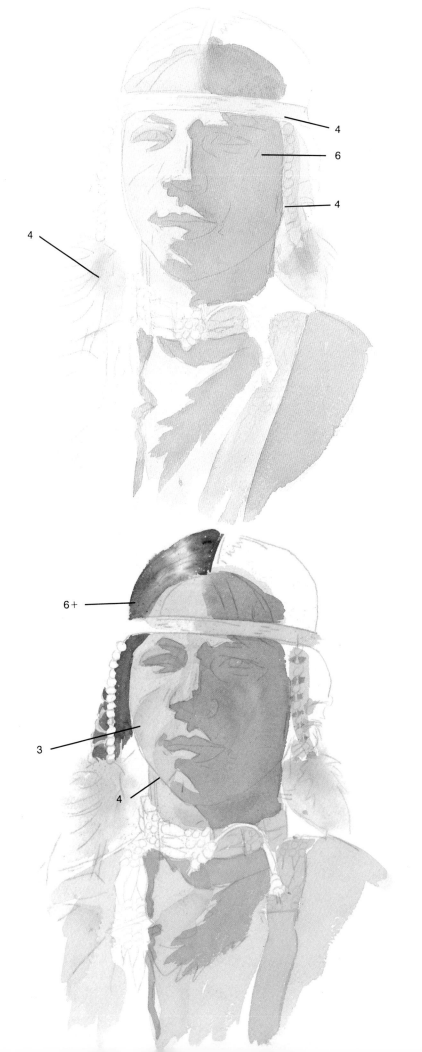

38

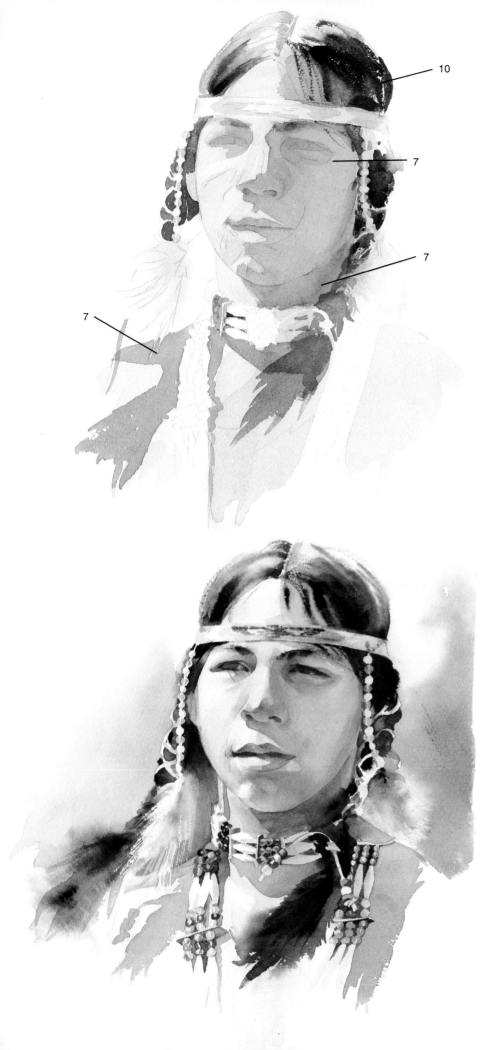

Step 4

This step and the previous one go on more or less simultaneously. Because most watercolor pigment is more or less transparent, every brushstroke serves to further darken and model the head. The cast shadows, which are somewhat darker, are added and used to define the edges of the jewelry.

In general I find it easier to paint the darkest areas last and leave the detail until almost everything else is painted.

Step 5

After the painting is thoroughly dry, it's time for the final phase. Using clean water, I wet a large area over and around the previously painted feathers, careful to avoid the face or any other place I do not want the background value to appear. Now, using a medium-size brush, I carefully paint around the feathers, permitting a soft white halo to appear between the feathers and the background. Next comes the final detail. I add the darkest darks to the eyes and hair, in the nostrils, and between the lips. The eyebrows are painted onto a slightly moistened surface. I paint the rest of the background and the brow-band last, then remove the construction lines with a soft eraser and the portrait is finished.

Demonstration
A Businessman

I know this man to be a friendly, gentle person, as well as a successful businessman. The challenge here is to present him in a more flattering (and realistic) manner. The photograph was taken indoors under artificial light, and while there is only one light source, the contrasts are harsh and unflattering. We live in Oregon where the sun is sometimes referred to as a UFO. Often natural lighting is difficult to obtain, so it is good to know how to deal with this circumstance.

The first step is to identify the simple shadow areas and then apply the 40 percent rule as if our subject were in full sunlight. By adjusting the value relationships correctly, we can work from any source regardless of the lighting and still create a portrait that glows.

The numbers on the photo correspond to the steps in the 10-step value scale and demonstrate the 40 percent rule.

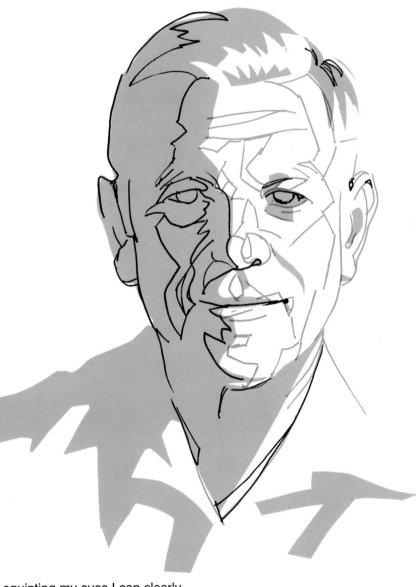

By squinting my eyes I can clearly discern the shadow pattern and facial planes, as seen in this diagram.

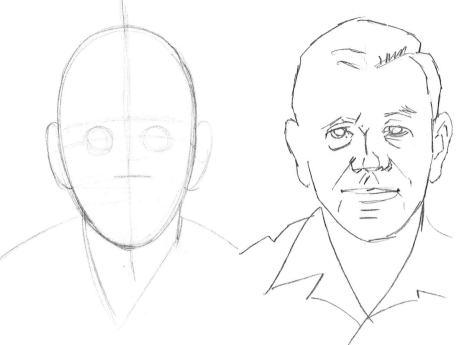

Once again I draw the head beginning with the basic ovoid shape. The shadow areas are emphasized in the third example.

Step 1

I paint the first wash over the entire face and neck. I wish I had left more white areas in the hair for highlights. Perhaps I'll remember to do that on the next portrait I paint.

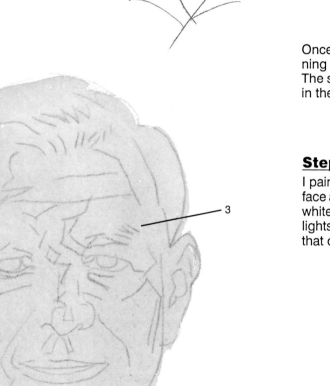

3

0

Step 2

As soon as the first wash is thoroughly dry, I carefully paint the shadow side of the face using a pigment 40-percent (or 4 values) darker than the sunlit side. The shadows on the shirt look dark in the photograph. However, I want my model to appear to wear a white shirt, so in accordance with the 40 percent rule, I paint the shadow side of the shirt value 4.

Step 3

Once again I let the painting dry. The facial planes on an older model are more distinct, and I enjoy using my brush, loaded with a wash that is slightly darker than the initial one, to make forms recede into shadow and thus carve the features with each stroke of my brush.

Step 4

The shadow side is complicated by the cast shadow that appears in various places due to the artificial light. I interpret these shadows darker than value 7. I simply apply a light wash of pigment over these particular areas to darken them.

7+

7+

3

7

4

Step 5

This is the final head with the construction lines removed and the darks in place. I think you will agree that the more favorable (sunlight) lighting did a great deal to give a more youthful appearance to the model.

Seeing Light and Color

In this chapter we are going to get to the heart of just what makes a painting glow with light. To achieve this illusion we must paint our subject as if it were in bright sunshine. Logically, to do this we must first understand what happens to objects of definite color identities when they are bathed in sunlight. This information on *light* is information you need no matter what subject you paint or what medium you use. Later, in the section on watercolor pigments, I will tell you why some pigments are better adapted to this purpose than others, and how to make luminous darks, thus avoiding the ever-present yucky "mud" that all of us have splashed on our watercolor paper at one time or another.

Even though some of this material may seem pretty basic to many of you, you may have forgotten some of the terms, or maybe you're a relatively new painter. Simple as it may sound, it took me years of painting before someone finally explained that "negative" painting simply meant painting around the subject. Terms can be confusing, and I want to be sure you understand every term I use.

Once you understand the laws and principles of light and color in this section, used in concert with the 40 percent rule, you may find (as I have found) courage to experiment with color, and a new sense of freedom based on knowledge.

It is the combination of the laws of light and color, applied with the 40 percent rule and expressed in pure, transparent colors that produces the glow you want in your portraits. The glow of light and life is the heart and soul of a successful portrait.

(left) "Summer Camp Remembered" 14½ x 20

Laws of Light

I believe that an artist's main job is *seeing,* and I also believe that the largest part of seeing color is knowing what to expect and where to look. Seeing light and color is great fun, and before long you may find yourself looking for the subtle nuances of color to be found everywhere in nature. In the following pages you may discover some new places to look and more beautiful things to see.

We all know that a pond mirrors the sky on a clear day. So does every other horizontal surface exposed to the sky. With this in mind, let's try an experiment outdoors. It's best to make these observations in the morning or late afternoon because the brilliant midday sun can make subtle shadows even less obvious.

Place a white or light-colored box outside on a piece of plain-colored wrapping paper. Arrange the box so that one side faces the sun and the cast shadow falls across the paper.

Notice that the top of the box reflects the sky, and is bluer than the vertical surface toward the sun. This sunny side may be lighter or darker in value than the top of the box, but it will appear warmer in hue (more toward yellow).

Now let's examine the shadow side. This surface is not only 40-percent darker in value than the sunlit side, but it may also receive reflected light from the paper upon which it is placed, or from some other nearby object in direct sunlight.

The cast shadow takes on the hue of the surface upon which it falls and is somewhat more than 40-percent darker than the surrounding sunny area.

Now we come to the warm "underneath" darks. These are the small darks that appear in crevices and under things. They are always warm because they are not influenced by the sky.

These subtle differences of color apply to every object viewed in full sunlight. It could be a cloud, tree, or brick wall; the color differences are there and you can see them if you look carefully. On cylindrical objects the cool area occurs not only on top (if there is one) but also where the sunny and shadow sides meet.

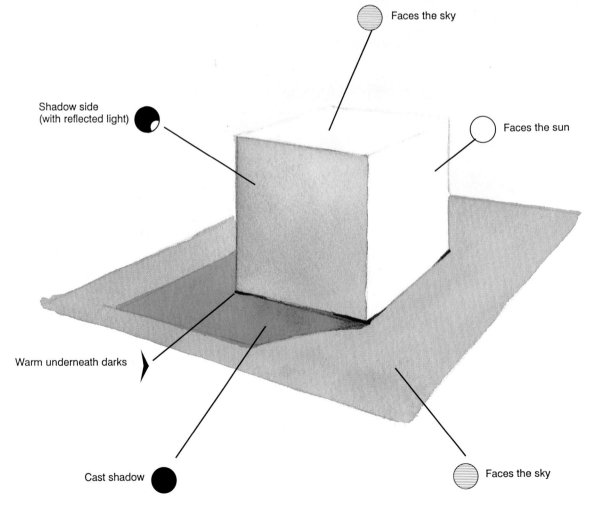

Faces the sky

Shadow side (with reflected light)

Faces the sun

Warm underneath darks

Cast shadow

Faces the sky

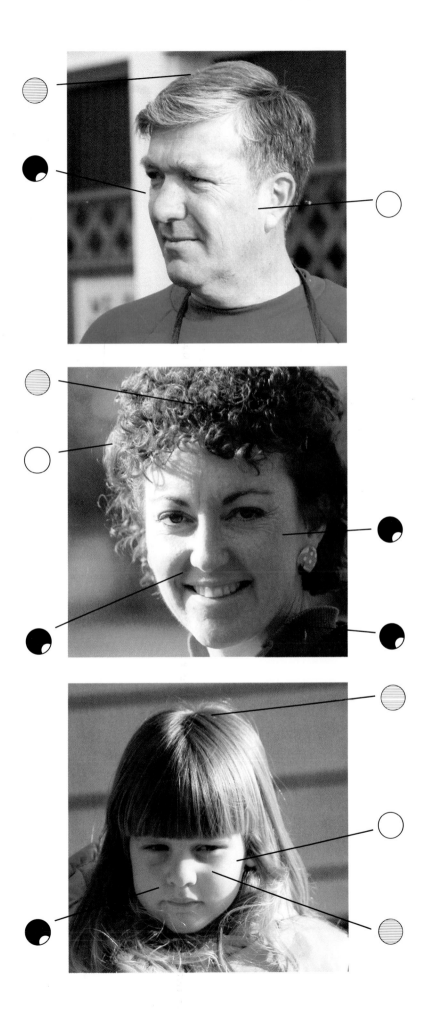

In this photograph we see a lighting situation very much like our box on the previous page. Like the top of the box, the hair reflects the sky, the man's left cheek faces the sun, and his right cheek is in shadow with reflected light.

This photo shows a face brightly lit from the side, creating a strong contrast between light and shadow that divides the face in half. Notice how the area in shadow reflects light from sources around the face, providing opportunity for colorful shadows.

This darling little girl's face is largely in shadow, but look at how the reflected light makes those areas glow with warm color. See how the top of the hair and the area under her left eye reflect the sky, providing a place for cooler color.

Light and Shadow

Here is the egg head again, along with some simple watercolor sketches to illustrate how information concerning light and shadow can prove useful to you when you're painting a head. These sketches have been marked with symbols so you can see how each facial area conforms to the "laws of light."

Notice the places where the sunny and shadow side meet. This area is oblique to the sun and is therefore somewhat cooler in hue.

With careful observation, the changes in color temperature on objects viewed in the sunlight will become increasingly apparent. No matter what subject you are paint-

ing—portrait, landscape, still life, or whatever—the 40 percent rule, used in conjunction with the laws of light will, when mastered, add immeasurably to your enjoyment of color, and permit you to use light in your paintings with increased confidence.

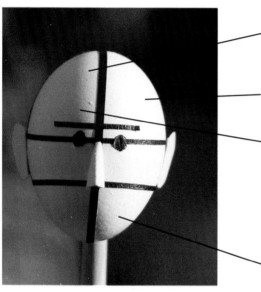

The color on the egg flows from near white (toward orange) to a cooler shade as it approaches the shadow side. The shadow side is 40-percent darker than the sunlit side and may contain reflected light. There is no reflected light in the cast shadow.

In this watercolor sketch the head looks a great deal like the egg. The flesh color (yellow-red) has been "cooled" with the addition of alizarin crimson as the face curves away from the direct sun.

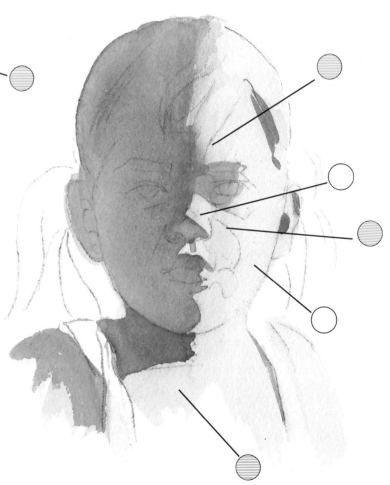

48

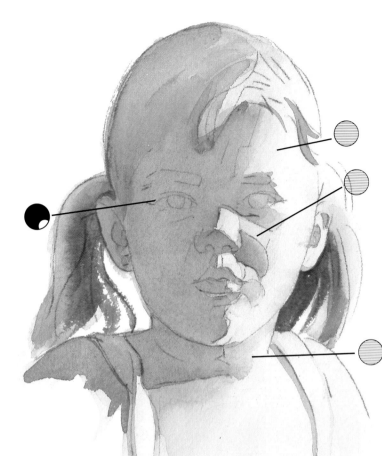

As the modeling of the face progresses, you can see how the change in color temperature adds to the illusion of roundness.

The change from sunlight to shadow on the egg is very much the same as it appears on the head. The flow of color and value is broken only by the features. The side of the nose and the side of the cheek receiving the sun's direct rays are toward orange. As the face curves from the light the colors cool, and on the shadow side they become fully 40-percent darker than on the sunlit side. It's on the shadow side that we can see the glow of reflected light. This simple transition from sun to shadow is the basis for all the painting to follow.

Color and Value

Primary Colors

Secondary Colors

Complementary Colors

Much research has been done and many books written on the subject of color. You may find it well worth your time to study this subject in some depth, and good books on this subject are listed in the bibliography. What matters most is how much of this information you can remember—and have at your disposal—when you are excited and in the creative process of painting.

For our purpose, I have boiled it down to some simple information that will help us in our quest for creating the illusion of sunlight.

There are three dimensions of color: *hue, value,* and *intensity.* Hue is the term used to name a color. Red, yellow, green, or blue, etc., are hues. Value is the lightness or darkness of a color. Intensity refers to the saturation, strength, or purity of a color.

Primary Colors
The primary colors are red, yellow, and blue. We call these hues primaries because they cannot be made from the combination of any other pigments.

Secondary Colors
The secondary colors are: orange, mixed from red and yellow; green, mixed from yellow and blue; and purple, resulting from the mixture of red and blue. All of the other colors are combinations of the three primaries and the three secondary colors.

Complementary Colors
Complementary colors are those located directly across the color wheel from one another. Yellow and purple, orange and blue, green and red are examples of complementary colors. When complementary colors are mixed the result is a neutral gray.

Color Temperature
When artists talk about a *warm* or *cool* color, they are referring to the quality of the hue. Generally speaking, the colors associated with fire—those centered around orange on the color wheel—are considered warm. Cool colors, on the other hand, are associated with ice, such as blue, green, blue-violet, etc. You may want to refer to the color "thermometer" if you have any doubt. To "cool" a color, then, you would add a color toward blue or green. To "warm" it, you might add red or yellow.

Value Range
Value range refers to the number of intermediate values we can mix between the darkest value straight from the tube and the lightest value when mixed with water. For instance, yellow has a very short value range. Even if we used it directly from the tube, we could never achieve a value

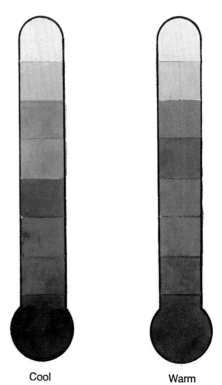

Cool Warm

Color Temperature

darker than 2 or 3. Alizarin crimson has a very long value range. It can be diluted to a value 1 and, in saturated form, can be made to appear almost black.

Opaque and Transparent Colors

You will soon discover that some watercolor pigments are more or less opaque. In small accents it is possible to achieve a fair degree of opacity, and now and then an opaque color can be used to paint over a transparent one to achieve a veiled effect. However, generally speaking, watercolor, as we are using it in this book, is a transparent medium.

Watercolor Pigments

Most professional watercolors are permanent, and are as enduring as oil pigments. In museums across the country you can see Chinese watercolor paintings that have lasted for hundreds of years, even though the fabric upon which they are painted is discolored with age.

We can assume that our pigments are chemically stable and permanent, but it is helpful to know a bit more about their properties.

As we discussed earlier, there are two kinds of watercolor pigments—*opaque* (sometimes called precipitating) and *transparent* (or staining).

Light rays penetrate the thin film of pigment deposited on the paper by staining colors and are reflected by the white of the paper, imparting a glow of color to the light (see below). The more that the white paper is allowed to reflect, the more luminous the effect. For that reason I find transparent pigments are best suited for our purposes of painting glowing watercolor portraits.

When light is returned from an opaque color, it reflects only the pigment granules (below right). Before long, you may be able to recognize the opaque pigments

from the way they flow onto the watercolor paper. They seem heavier, and are easier to manipulate than the free-flowing transparent ones.

In addition to the differences in opacity or transparency and value range, is the question of how much, if any, black is contained in the pigment. There is no black or white in the spectrum, therefore they are known as neutrals, along with all the other hueless grays. By knowing which pigments contain black, we can avoid them, or restrict their use to light value passages. With this knowledge we can select colors for clarity and brilliance.

The following pages describe the pigments I use most often. Almost every manufacturer makes good transparent watercolors, but my observations refer to Winsor & Newton colors. If you experiment with other brands of color, you may find some variation, but they will be remarkably close.

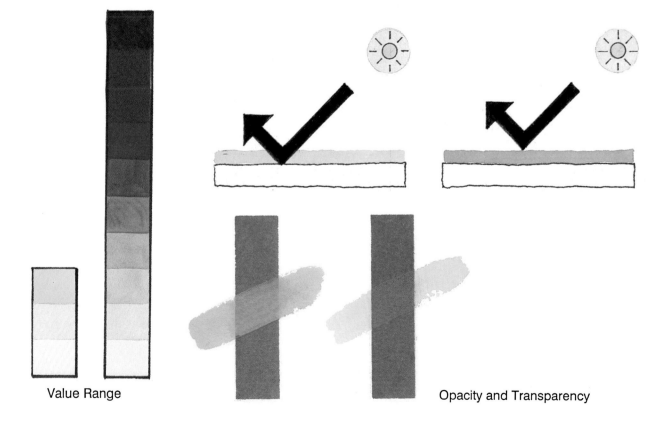

Value Range

Opacity and Transparency

51

GROUP 1: High-Intensity Opaques
These pigments have a very short value range. They are useful for bright accents and over-painting in small areas.

Cadmium Yellow A warm (toward orange) intense yellow. Can be mixed with cadmium red to produce light value skin tones. Very opaque. Can be used for bright accents.

Cadmium Orange A pure, opaque orange. Mixed with Winsor blue or Winsor green results in a rich grayed green. I use this orange to introduce reflected light into the shadow areas.

Cadmium Red An intense (toward orange) red. Never a very dark value, even when used full strength. Useful in placing a "rosy glow" wherever needed.

Vermilion I seldom use vermilion. I usually substitute cadmium red because it has most of the properties of vermilion, but is slightly less brilliant (and less expensive).

Cerulean Blue A heavy, chalky pigment, greenish blue in character. Use to suggest gray hair and sometimes to cool facial areas. With yellow ochre it could suggest white in shadow.

Cobalt Blue Close to a pure primary blue, and somewhat transparent. Combines well with other pigments to create beautiful secondary colors in light values.

GROUP 2: Low-Intensity Opaques
These pigments have varying value ranges, but used alone in dark values, they appear lifeless.

Yellow Ochre Mixed with cadmium red, makes a good skin tone for light-value areas. A favorite of many painters, but I seldom use yellow ochre.

Raw Sienna A glob of raw sienna on the brush, dragged across a wet area, leaves an uneven path that translates into blond hair when laid alongside green or blue.

Raw Umber Contains a lot of black. I like to use raw umber with phthalocyanine blue (in middle values) to create the cool areas around eyes.

Burnt Sienna A burnt orange color, and a favorite of landscape painters. Mixed with blue, it creates wonderful grays. I like to mix it with alizarin crimson for warm dark areas.

Burnt Umber Mixed with alizarin crimson, makes wonderful warm blacks for those small areas in complete shadow. Burnt umber should never be used alone, especially in dark values.

GROUP 3: Low-Intensity Transparents

These colors have a long value range. They can be diluted to pale delicate colors, but when used with less water, they appear very dark. However, like the low-intensity opaque colors, these pigments appear dull and lifeless if used alone in values darker than 6.

Brown Madder (Alizarin) This is beautiful, rich, red-brown. Combined with new gamboge, it makes a brilliant substitute for burnt sienna.

Indigo I seldom use this blue-black pigment. Sometimes useful as a very light value glaze to cool "hot" passages. A real "garlic" color: A little goes a long way!

Payne's Gray Mixed with Winsor blue, or laid next to burnt sienna, suggests black hair. Can become habit-forming, and overuse can result in gray paintings.

Sap Green An intense (toward orange) green. Stains the paper and is difficult to conceal. Use this color with raw sienna or raw umber to suggest a cast shadow around the eyes.

GROUP 4: High-Intensity Transparents

These brilliant pigments—unlike those in Group 3—remain luminous at all value levels. They're useful for glazing, and mix well with other pigments to achieve lively darks. Remember, these pigments can stain other pigments as well as the paper.

New Gamboge A brilliant clean yellow and my favorite yellow. (Don't confuse this color with *gamboge*, which is dull by comparison.) Mixes well to make beautiful secondaries.

Winsor Red Has great strength, but not quite as transparent as others in this group. Tends to dry a bit flat. Can be used to intensify other reds.

Alizarin Crimson A cool, very transparent red with a long value range. Mixes with burnt sienna or burnt umber to make beautiful warm darks or with ultramarine blue for a luminous purple.

Winsor Blue Another "garlic" color. A cool transparent blue, beautiful by itself, but tends to dominate and should be modified with another color. Also called Thalo or phthalocyanine blue.

Winsor Green Cool in character and very intense. Try this color laid next to raw sienna to suggest silver jewelry. Also called Thalo or phthalocyanine green.

French Ultramarine Blue Can be considered a transparent or opaque pigment. Tends to dry lighter than expected. Combines with many pigments to make clear secondaries.

53

Properties of Watercolor Pigments

Pigment	Darkest Value	Opaque	Paper Staining	Transparent	Black Content
GROUP 1: High-Intensity Opaques					
Cadmium Yellow	2±	Very	Slight	No	None
Cadmium Orange	3±	Very	Slight	No	None
Cadmium Red	4±	Very	Slight	No	None
Vermilion	4±	Yes	Slight	No	None
Cerulean Blue	4±	Very	Slight	No	None
Cobalt Blue	5±	Yes	Slight	Slightly	None
GROUP 2: Low-Intensity Opaques					
Yellow Ochre	3±	Yes	Slight	No	Slight
Raw Sienna	4±	Yes	Medium	No	Slight
Raw Umber	6±	Yes	Slight	No	High
Burnt Sienna	6±	Partly	Medium	Slightly	Slight
Burnt Umber	8±	Yes	Slight	No	High
GROUP 3: Low-Intensity Transparents					
Brown Madder (Alizarin)	8±	No	High	Yes	Medium
Indigo	9±	No	High	Yes	Medium
Payne's Gray	10	No	Medium	Yes	Medium
Sap Green	6±	No	High	Yes	Medium
GROUP 4: High-Intensity Transparents					
New Gamboge	2±	No	Slight	Yes	None
Winsor Red	5±	Slightly	Medium	Yes	None
Alizarin Crimson	8±	No	High	Yes	None
Winsor Blue	10	No	High	Yes	None
Winsor Green	10	No	High	Yes	None
French Ultramarine Blue	8±	Slightly	Slight	Nearly	None

The Color Wheel

The color wheel presented here conforms with most of the color wheels I have seen, presenting yellow on top and purple at the bottom. This divides the wheel in half, with the warm reds on the left and cool colors on the right. While red and orange are cooler than yellow, they are warmer than the blues on the right side of the wheel. However, all the colors become warmer as they approach yellow at the top.

The color wheel makes some very basic color relationships easier to see and understand. The three primary colors are located equidistant from each other. Any two primaries mixed together create a secondary color, placed between the two parent colors and opposite the remaining primary color. Thus, purple, which is the combination of red and blue, is opposite yellow, and so on. Since a secondary color contains two primaries, when mixed with its opposite, all three primaries are present and a neutral grayed color is created. This is true of any two colors opposite each other on the color wheel, since theoretically any two such colors together contain all three primaries.

If an artist wishes to darken a color without it getting gray or muddy, then adding its complement would be a poor choice, since that is the formula for a neutral gray. A better choice would be to select a color from the *same* side of the color wheel, not opposite. This is the key to rich, "brilliant" darks. By adding a transparent dark from the same side of the wheel, you can mix shadow colors that are lively and exciting.

Warm

New gamboge

Yellow-orange Yellow-green

Orange Winsor green

Warmer ▲ Cooler ▼

Red-orange Blue-green

Winsor red Winsor blue

Alizarin crimson French ultramarine

Purple

Cool

Brilliant Darks

Beautiful clear darks are an asset to any watercolor, but in portraiture they are doubly valuable. A pretty face is no place for mud!

Complementary mixtures, as we have seen, result in grayed or neutralized colors. In dark values, these mixtures are muddy and lifeless. Combine these with dirty water or polluted pigment, and it's time to reach for the seed catalog because you've got *mud*.

There are some pure colors that are capable of dark values, but if they contain black, they too may appear flat. These are the pigments in Groups 2 and 3. The answer to obtaining brilliant darks is to combine these pigments with the long-value-range transparent colors to be found in Group 4.

Here's how it works. Let's say you are painting a person whose complexion in sunlight is a value 3. The flesh tone is a rosy orange. The 40 percent rule tells you that you must use a value 7 for the shadow side. It's obvious by checking the pigment chart on page 54 that cadmium orange, even at its most intense concentration, can achieve a value of only 3. So what should you do to arrive at the proper value? You might be tempted to try blue, but that will neutralize the orange. Burnt sienna is the obvious choice, but it contains black, and in dark values will appear dull. So, even if you could achieve the proper value with burnt sienna, a better solution is to reach for alizarin crimson. Combine this brilliant long-range pigment with burnt sienna. Not only will this combina-

This is Ehab, my handsome young Egyptian friend. He has olive skin, and the shadows look quite green. I painted the skin with a mixture of raw sienna and burnt sienna (value 2). The shadows are a mixture of raw sienna and sap green (value 6). I lifted some of the color along the jawline and added cerulean blue. The hair is Winsor blue, sap green, Payne's gray, plus a few drops of pure burnt sienna here and there for warmth.

tion satisfy the value requirement, but it will result in a brilliant clear dark.

Let's try another color. Suppose our model is wearing a dark shirt. We know from our understanding of the laws of light that the front of the shirt, facing the sun, will be "warmer" than the top of the shoulders, or where the sunny and shadow sides meet. These areas will be much cooler by comparison. To paint this shirt, I would add a suggestion of yellow-orange ever so lightly to the color in sunshine. Next I would "cool" the top of the shoulders with a hint of Winsor blue. The shadow side should be neutralized with blue-gray. This shadow would be a value four steps darker than the color in sunshine. I would probably want to add some reflected light on this shadow side to further enhance the color.

Here are some additional tips to help you add glow to your darker values:

1. When adding a complementary color, float it into the still-wet dark and let it merge on the paper. Don't stroke or stir.
2. Add color for reflected light everywhere you can.
3. Make the edge of the shadow farthest from the object that cast it cooler. When your eye sees a shadow, you subconsciously compare it with the warm sunlight around you, which makes the shadow look even cooler in contrast. However, the *center* of the shadow will not look as dark because it isn't contrasted with the light.

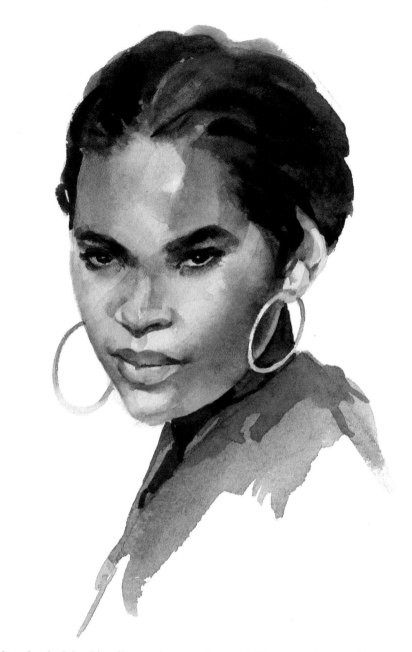

This sultry lady's skin glistened a warm brown in the sunshine, and became a rich violet in the shade. Her skin is painted with burnt sienna and cadmium red (value 3+). The shadows are Winsor blue and alizarin crimson (value 7+). I dropped in Winsor green around her eyes. Her hair is Winsor blue with streaks of Payne's gray. I dropped in a burnt umber here and there for a black accent. The shirt collar is pure Winsor blue at the back, and I added burnt umber at the front while the blue was still wet. Any time I use a complementary color I drop it into a wet area and let it merge on the paper. When you drop in a color, generally at least part of it remains in its pure state, and becomes an accent rather than a dull mix.

Skin Tones

Before I begin to make suggestions for various color combinations, I want to emphasize the importance of keeping your palette, paint, and water clean. A clean palette is to no avail if the pigment wells are dirty. Our goal is brilliance and glow, and it is impossible to mix brilliant colors with grayed pigments.

Colors appear different on the palette than they do on the paper, so keep a scrap of watercolor paper handy to test color intensity and value. When you try these mixtures I suggest you begin with red and add yellow as needed. It's easier than you think to make a person appear jaundiced. Finally, mix as much color as you can on the paper. This is another way to get more brilliant color.

I select my colors from among the pigments that contain little or no black. If you will refer to the color chart on pages 52 and 53, you'll find them in Group 1—*high-intensity opaques*, and in Group 4, *high-intensity transparents*.

When mixing skin colors in values lighter than 6 there are many possibilities open to us. This is because it's only in darker values that the real possibility of creating muddy colors is likely to occur.

Bear in mind, the value of these initial skin tone mixtures will determine the values in the rest of your portrait.

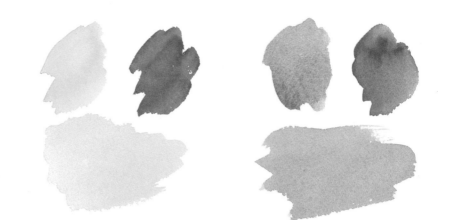

Let's begin by choosing from among the long-value-range, transparent colors in Group 4. For children and older people with fair, golden skin, you could use Winsor red and new gamboge. If that seems too "hot," substitute alizarin crimson. This "cooler" mixture might satisfy for people with dark hair and very fair skin.

There are places around the eyes and temples where the skin appears cooler than in the center of the face. I sometimes wash out my brush and add a cool color, such as a pale passage of Winsor (phthalocyanine) blue or a touch of green, right into the skin color mixture as I approach these areas. With practice you will gain enough control of the medium to make these subtle temperature changes wherever you wish.

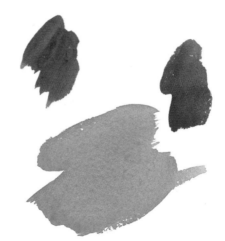

Now let's make other selections using the pigments in Group 1. These short-value-range, opaque pigments contain no black and therefore will appear fresh and brilliant. Cadmium red mixed with cadmium yellow is a good choice. I sometimes substitute Winsor red or alizarin crimson for cadmium red when I want a cooler skin tone.

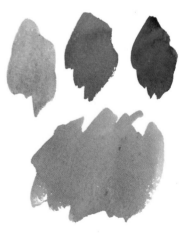

With darker complexions we are forced to use pigments with some slight black content, but we can combine these colors with pigments that contain no black to enhance their brilliance. I recommend cadmium red mixed with raw sienna or yellow ochre for dark complexions. Another choice might be burnt sienna with alizarin crimson.

Reflected Light

Reflected light is just that—*light*. We know this light may appear on the *shadow* side of objects due to the reflection of light from an *adjacent* object that is in full sun. We also know that the color of reflected light depends on the color of the object that reflects it. This knowledge becomes an "open sesame" to the artist in search of brilliant color.

Once again I call upon egg head to help demonstrate this phenomenon. (By now egg head has become a reliable colleague and has been named E.H.) This time I photographed E.H. next to a wall upon which I pinned various colored papers. The shadow side is still clearly visible but now it is aglow with brilliant color!

Never forget that the simple *shape* of the shadow area is critical to the portrait. If you also observe the 40 percent rule, all that's left is to make the shadow area glow with the color of the reflected light.

With watercolor pigment, the trick of suggesting reflected light in a convincing manner is all in the water. If you have too much pigment and not enough water on your brush, the paint will just sit on the paper and you'll get a streak. If you have too much water and not enough pigment, the paint will spread in a weak puddle and you'll lose the intensity of the color. Since watercolor usually dries lighter than it looks wet, I suggest you practice this water/pigment ratio on scraps of watercolor paper.

A watercolor should look fresh and spontaneous, but that doesn't mean it must be painted in a fast and uncontrolled manner. There are times when a particular passage is just too difficult or complicated to accomplish with one or two simple brushstrokes. When you are confronted with such a problem, it's best to break it down into layers or smaller units and paint each one in the simplest, purest way. It doesn't matter how you do it, just remember it's the end result that counts.

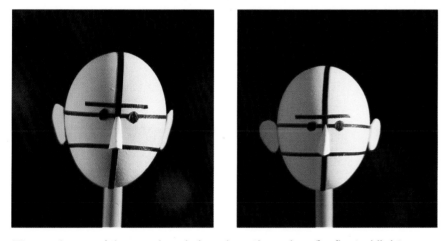 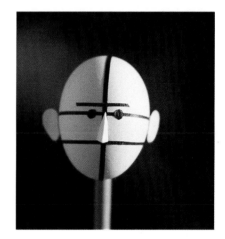

These photos of the egg head show how the color of reflected light can make the shadow areas glow with color. Reflected light not only transforms dull shadow areas into areas of color, it can enhance the color in the light areas by contrast. A cool, colorful shadow will make warm, sunlit areas look even warmer.

Demonstration
Pretty Penny

In this demonstration I'm working only with the shadow side of the head. I'll leave the rest of the modeling for later demonstrations. The goal is to make the side of this lady's face glow with rich color. The first step is to select long-value-range colors and use them to paint the shadow side 40-percent darker than the sunny side. At the same time I'll add reflected light to further brighten the shadow side.

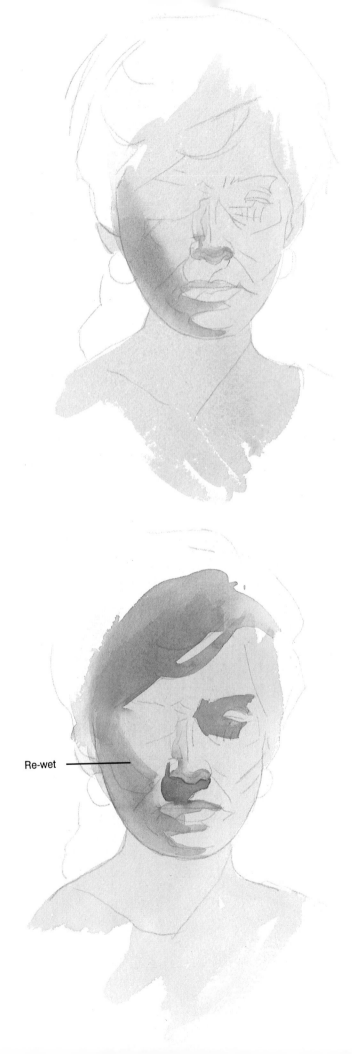

Step 1

I have drawn the face carefully and have already added a wash of the basic skin color. After this first wash is thoroughly dry, I mix two puddles of pigment: one of new gamboge, and another of a mixture of burnt sienna and alizarin crimson. After testing for value, I paint the new gamboge along the jaw line. Immediately I dip a clean brush into the alizarin crimson mixture and paint into the cheek area, letting the color flow into the yellow passage. I do not paint over the yellow, only up to the wet edge. Then with a brush dipped in clean water, I soften the edges at the cheek. Notice I paint the bottom of the nose in the same manner since it, too, receives reflected light. The entire passage is allowed to dry.

Step 2

I want the color of the reflected light to change to green along the top of the face, so I re-wet the top of the cheek with clear water. This time I add sap green, and immediately follow with a clean brush dipped in the same alizarin crimson/burnt sienna mixture. (In this illustration I permit the pigment to leave a slight edge so you can see the brush-strokes.) Next, I add a bit more pigment and paint the cast shadow under the nose. I use grayed green (green plus a touch of alizarin crimson) to paint the cast shadow in her left eye.

Re-wet

60

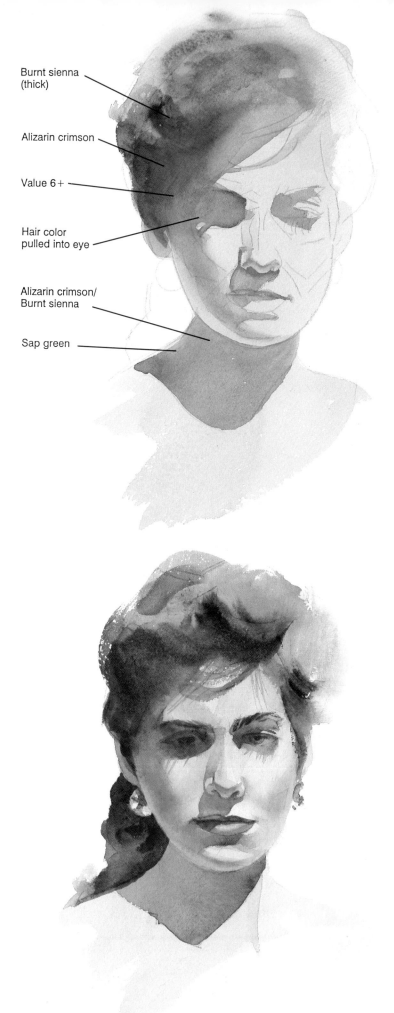

Burnt sienna
(thick)

Alizarin crimson

Value 6 +

Hair color
pulled into eye

Alizarin crimson/
Burnt sienna

Sap green

Step 3

Here you see the shadow side completed. Now we are ready for the middle values and final darks. In this step I wet the side of the temple and paint the shadow side of the hair using rather thick amounts of pigment. Then I pull this color down into the cast shadow area on the right eye. You can see I have used a great deal of color, but a single light source is maintained.

Step 4

This is the finished vignette. Here you can see that it is the reflected light on her cheek, with the dark background of the hair acting as a foil, that gives ''glow'' to this portrait.

Demonstration
A Businesswoman

Now let's follow the complete painting procedure, this time with a smiling face. The drawing process is the same, with some simple adjustments to the mouth. If you look straight into a mirror, you'll notice that the corners of your mouth are just about under the centers of your eyes. When you smile, the corners approach the outer edges of your eyes, and a little depression forms in your cheek. Usually, only the middle six teeth are clearly visible: the incisors and two or three on either side.

The woman in this demonstration is painted from a sketch I made some time ago. I wanted to sketch a smiling face, so she exists only in my imagination.

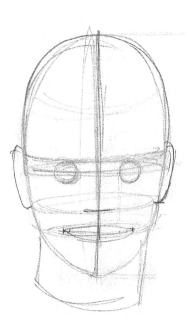 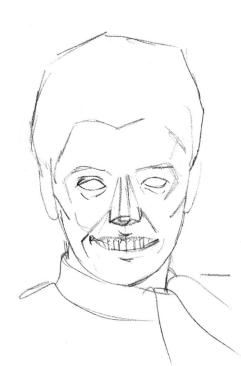

In the first sketch above, I start with the basic ovoid shape and locate the features. This time I draw the mouth to reach the outer edges of the eyes.

Using a fresh piece of tracing paper I draw the eyelids over the contour of the eyeballs, block in her nose, and add teeth. The centerline of her face divides her incisors, and I block in several teeth on either side.

I complete the sketch of the head, and turn my attention to the location of the shadows. Here I refer to my original sketch (far right). Notice that the cheek on the sunlit side curves around to the shadow side and casts a shadow on her upper lip. The diagram will help you see the shape of the complete shadow side.

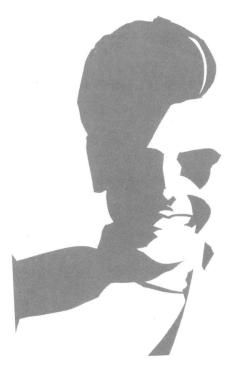

62

Step 1

Now that I have the complete picture in my mind, I trace the face onto the watercolor paper. The initial flesh color is a mixture of new gamboge and cadmium red. I bring that flesh tone into the hairline and across her eyes and teeth. Next I add cerulean blue to her hair and cobalt blue for her blouse.

Step 2

Now for the shadow side. This is fun because I feel a certain freedom knowing the reflected light can be any color I want to choose. My main concern is keeping the value relationships correct. Any glaring color problems can be glazed over in the next few steps. Notice that the shadow color is painted across her teeth. Teeth are never snowy white, as much as we wish they were!

Alizarin crimson

Warm gray applied
to corners of mouth

Step 3

Using middle values of cadmium red, alizarin crimson, burnt sienna, and cobalt blue, I begin modeling the facial planes on the sunlit side. The area around the forehead is somewhat cooler in hue than the middle of her face. Using a warm gray, composed of a mixture of cobalt blue and burnt sienna, I paint the outer edges of her teeth. Then, using clear water in a clean brush, I pull the two sides together across the front of her mouth. This gives the effect of the curve of the dental arch.

Step 4

Back to the shadow side. This time I add Winsor blue and raw umber to my palette. Since hair has soft edges, I work wet-into-wet. Sometimes I pull color from the hair across the forehead to further enhance the soft feeling. I go more slowly now, and begin delineating the features in shadow.

Step 5

Eyebrows require special treatment. I dampen the area with clear water and place a rather intense spot of raw umber near the center of each brow. Before this has a chance to set, I use a small brush dipped in a puddle of slightly diluted cobalt blue and draw the raw umber/cobalt blue mixture out along the brow line.

Finally I erase the construction lines and add a twinkle to her eye by picking out a spot of white paper with the aid of a knife.

If you are painting along with me, and are new to portraiture, I'll bet you had trouble leaving that shadow across her teeth. It sometimes takes courage to paint the shadows over the *entire* shadow side. Aren't you glad you did?

Demonstration
Aunt Rosemary

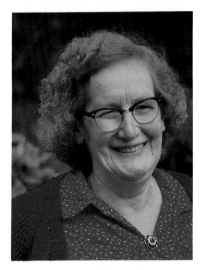

Just one look at Rosemary and it's easy to remember all the good things about childhood. Apple pie, homemade bread, and tender loving care all smile from this lady's face. It's more fun to paint someone with whom you can feel an emotional involvement.

Here is Rosemary photographed in front of her home in Albany, Oregon. This time, in addition to studying the shape of the shadows and the facial planes, we must pay special attention to her glasses and the pin she wears on her dress. The shape of her glasses helps identify her, and her pin may be something she has always worn. It could have special meaning to her family. (I cherish the pin my Grandmother always wore at her neck.)

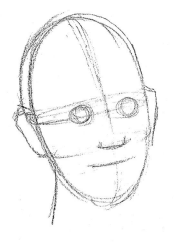

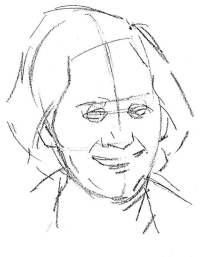

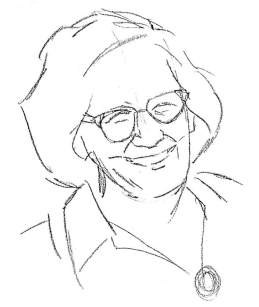

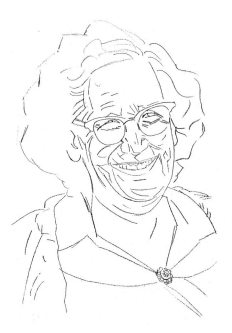

Let's take a close look at the color in Rosemary's face (see photo at top). Her skin is very fair and has a transparent look. There is a cool blue reflected light immediately above her glasses on her right side, and I see blue-violet shadows about her eyes and forehead. There is a warm yellow glow under the tip of her nose and on her cheeks, but it is the beautiful red glow on her neck and chin, reflected from the red dress, that adds warmth and color to the whole picture.

Rosemary's head is tipped to one side, but our view is almost straight-on. I draw the facial ovoid first to locate the features. Then, using tracing paper overlays, I develop the drawing a step at a time, outlining the shape of the shadows on the final sketch.

Squint your eyes as you study the photograph and compare the shapes of the shadows you see with those in this diagram.

Step 1

The size of the brushes I choose depends on the size of the area I wish to paint. In this first step I'm using a no. 10 round brush because the area is large and uncomplicated. As the painting develops, I will choose smaller brushes accordingly.

The first wash is a mixture of Winsor red and new gamboge. Before it has a chance to dry, I add cerulean blue and a streak of new gamboge to the sunny side of the hair. The entire head is painted. Eyes, teeth and glasses are included in this initial wash of color, which is value 1.

Step 2

The shadows are painted next. The colors are a mixture of cadmium red and burnt sienna. The value, in accordance with the 40 percent rule, is 5. The shapes of the shadows are complex, so I decide to paint them in the four sections you see outlined here. I begin at the tip of her nose with new gamboge and immediately add the cadmium red/burnt sienna mixture, washing out my brush between colors. Her left cheek is treated in the same manner. The cool area about the eyes is painted with a mixture of ultramarine blue and alizarin crimson. The temple area comes next. This time I use cerulean blue to represent that reflected light we see above her glasses, and immediately add the violet mixture. Notice that it's easier to control the edges when you paint small areas at a time. Now for the rest of the shadow area. Picking up the cadmium red/burnt sienna mixture, I begin by carefully painting under her nose, across her lip and into her cheek. Using a clean brush, I add new gamboge to the wet pigment and carry it along the jawline, then change to pure cadmium red deep as I approach her chin. This deep red will represent the red glow from her dress. Notice that this shadow area closely follows the pattern of the shadow diagram on the previous page.

Step 3

At this stage of the painting I use my brush very much as a sculptor might use a carving tool. After studying the facial planes, I use a light value pigment (value 2 or 3) to paint in any area that I want to "push back." These brushstrokes appear casual, but their placement is carefully studied.

In this step I add darks to the hair. From the section on the laws of light we know that vertical surfaces are warmer than horizontal ones, so I apply this knowledge to the placement of color in the hair. Next, I use liquid frisket on the dress area to suggest a pattern of white dots. The use of liquid frisket will permit me to paint the dress without painting around each dot.

Step 4

Now I can add dark detail to the painting. I moisten the area of the eyebrows with clean water and dab a bit of raw sienna in the darkest portion, permitting the moisture to carry the pigment across the brow. The eyes are suggested and a dark warm color is added to the corners of the mouth. After the red dress is painted, I use a rubber cement "pick-up" to remove the liquid frisket. It's possible to remove this masking material with an eraser or by peeling or rubbing with your fingers.

Step 5

Now for the final detail. The glasses come first. I am careful to draw them accurately. If they're obscured by too much color, I could re-place the tracing paper and freshen the lines. Fortunately the lines are still visible, so I begin to paint the outline of the rim right over her cheek. Notice that I let my line break and become darker in some places to suggest sunlight bouncing off the surface. I don't want the glasses to look like they're pasted on. The tops of the rims I paint much darker. I bury the ends of the temple pieces in the hair. Next I define the teeth and darken the corners of her mouth. Finally, after I model the folds of the dress and paint in the sweater, I give attention to her pin and render it with enough accuracy to make it readily identifiable.

2.

The Portrait

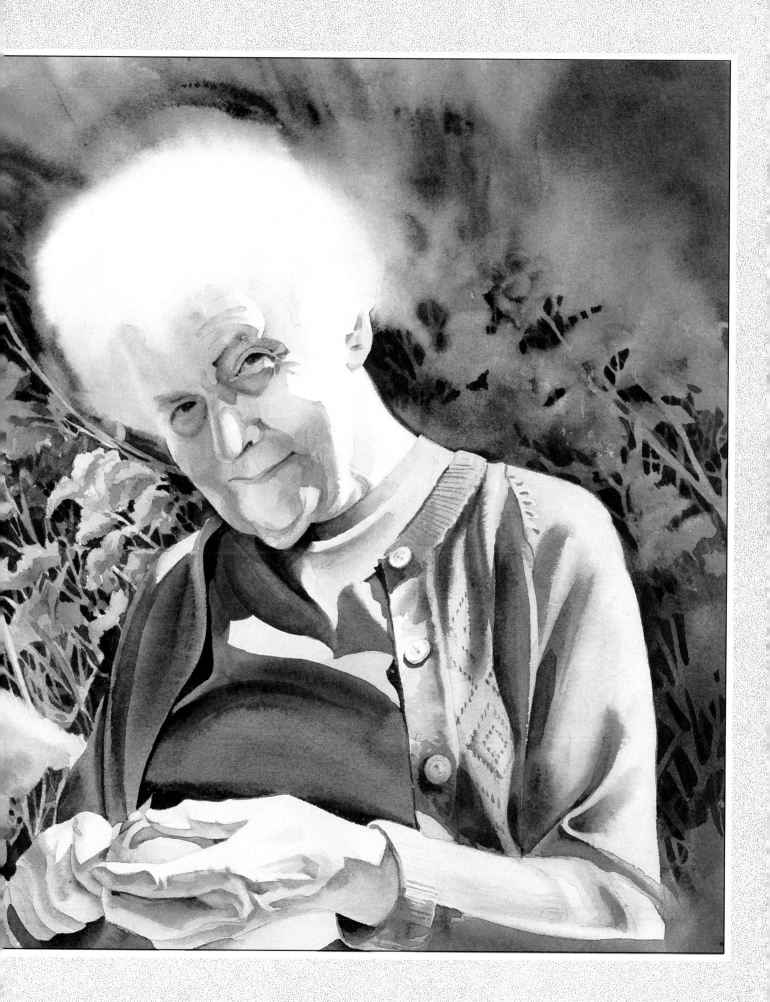

Looking at Your Subject

In the following pages, I will show you how I paint two different portraits, explaining my entire painting process from selecting a subject to the finished portrait. I will try to show you what I'm thinking about as I work, giving the reasons for the decisions I make along the way. The first portrait is of a lovely young woman named Pat, one of my favorite models, and the other, a mischievous little boy called Jon-Marc, who makes me think of Huck Finn.

Before we select our subjects, I want to emphasize that it takes two to paint a portrait. This part of portraiture you don't accomplish with a brush. You have to do it with your heart. Your portrait will suffer if you don't really feel something for your model. Ask yourself, "What is it I want to say about this person?" I find it helpful to write the answer to that question on the corner of my drawing board every time I begin a portrait. My note serves to keep me focused on my initial emotional response.

Norman Rockwell said it a long time ago: "People get out of your work just about what you put into it, and if you are interested in the characters that you draw, and you understand them and love them, why, the person who sees your pictures is bound to feel the same way."

(right) "Tea and Reverie" 15 x 20

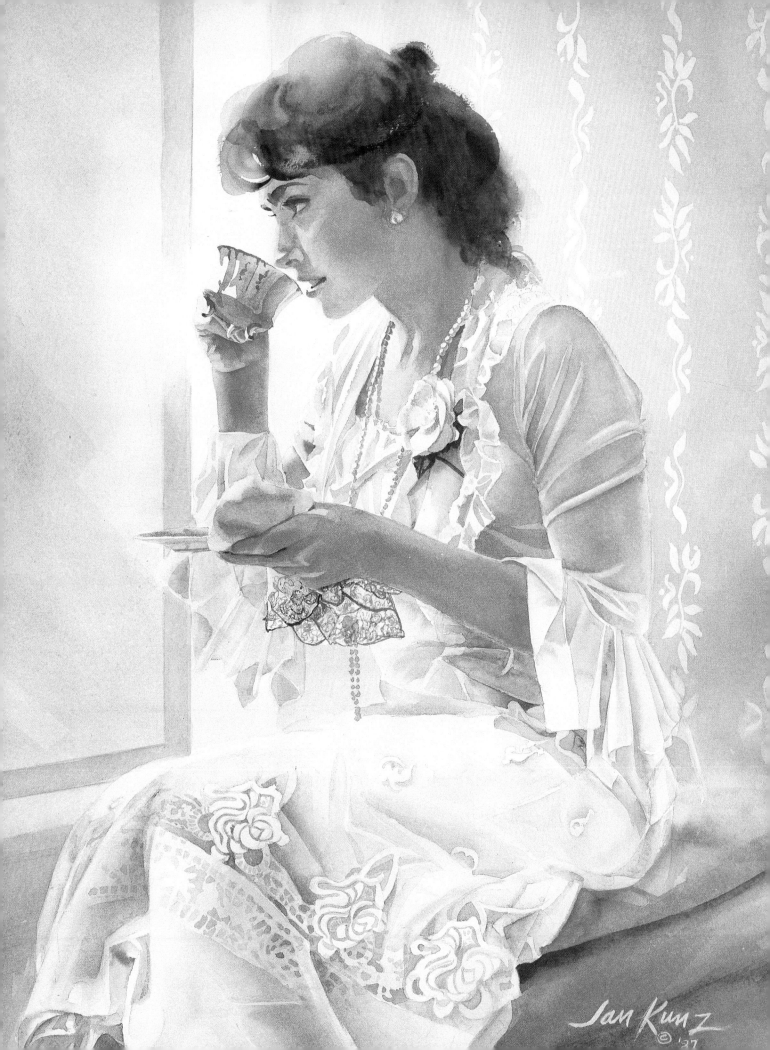

Live Model or Photo

You can see more and you can see it better when you paint from a live model than you can when painting from a photograph. It's as simple as that. There are many other advantages to having a live model, not the least of which is the important opportunity to get to know the person and sense the personality behind the face.

But let's admit it, outside of a classroom situation, it's not always practical or feasible to have a person sit for the length of time required to complete a work. With children, I find that an interview and a lot of photos is the best way to go. Just because the artist worked from snapshots doesn't make a portrait bad. Once the portrait is completed it must stand on its own merit. Almost all professional painters, even the best of them, use photographs to some extent.

If you are new to portraiture I suggest you paint someone you know. Paint from several photographs, working alone in your own surroundings. That way you'll feel comfortable and can concentrate on painting. After you are more sure of yourself, there will be time to work from a model. Only you know how you feel. If you have the opportunity to paint from a model, go for it! Every artist starts at the beginning, and you should never be ashamed of any sincere effort. Only your mother thinks you're wonderful when you first start!

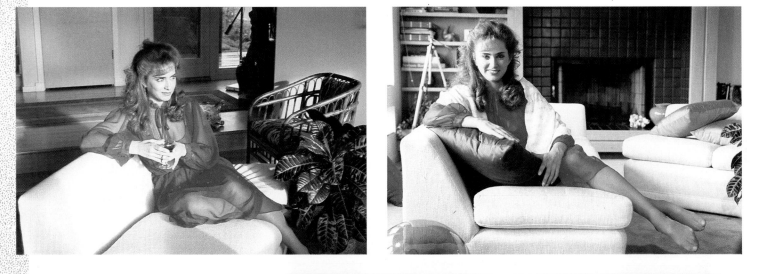

The model, Patricia Patrick, arrives with an assortment of clothing. She brings everything from party dresses to slacks. At this point we don't know which costume she'll wear. Our first choice is a red dress, but the brilliant color challenges her face for attention (above).

We attempt to soften the look with the addition of a scarf (above right). I like the way the scarf frames her face, but we decide that an informal pose would be more in keeping with Pat's outgoing personality.

Changing to a simple cotton blouse, Pat at once seems more relaxed. We're on the right track.

Pat has a habit of putting her hand in back of her head. Perhaps this gesture should be incorporated into the final pose.

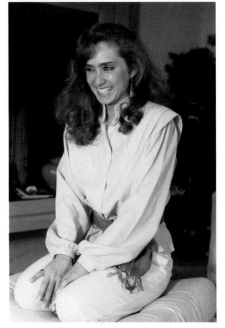

Posing a Model

If you're working with a live model, setting up the pose is the first step. Let's start with a few basic tips. Place your model in a setting that's in keeping with the mood, age, or occupation of the sitter. For instance, an elderly woman would look natural in a comfortable chair, or a rancher might have a saddle or some other related paraphernalia nearby.

Be sure your model is in a comfortable position. If she has a habit of tilting her head in a certain way, paint her that way. Your models will squirm less if they are posed in a position that is natural to them.

In order to re-create, as near as possible, the procedure of setting up to paint from a model, I enlisted the aid of Lynn Powers, a talented artist and graphic designer, to follow us about photographing the model and me at work.

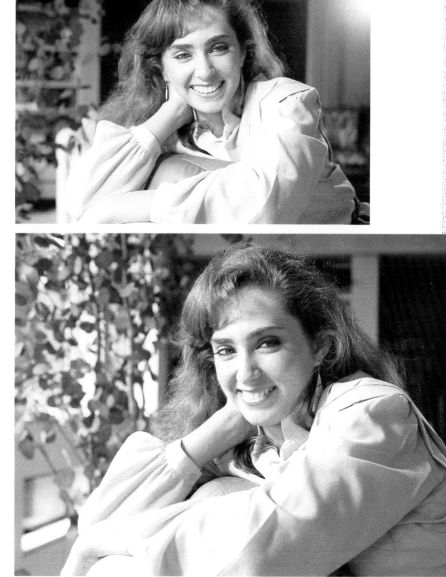

This setup above is discarded at once because the basket of branches and the glass fishing float are unrelated and distract from the subject.

The foreshortening of the model's left arm makes this pose at top right undesirable.

This is it! The position is natural and easy to reassume. The leaves and branches in the background create visual entertainment but do not overwhelm the subject.

Selecting a Photograph

Some subjects are easier to paint if you are working from photographic sources. I usually paint children from snapshots. It's best to take photos while the child is at play. I try not to be obvious, and I take a great many shots in rapid succession. This is good advice even if your subject is an adult. The point is to obtain a photo that doesn't look stiff or posed.

Here are several photographs of children. Some are considerably easier to use for painting material than others. Photographs with clearly defined shadows, enough reflected light to reveal facial forms, and a flattering, unobstructed view of the face make the painter's job easier.

However, even as I make these assessments of the photographs pictured here, I know that there are many painters who might do a masterful job using any one of them. Art comes from the heart, and anything is possible. But keep in mind that the chances of success are best when the subject is kept simple!

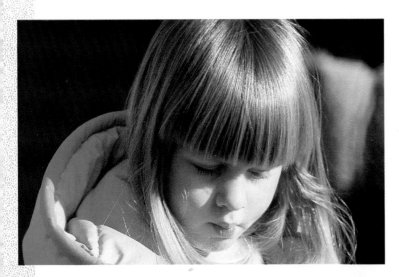

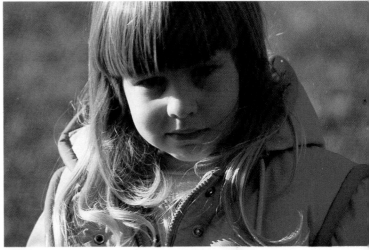

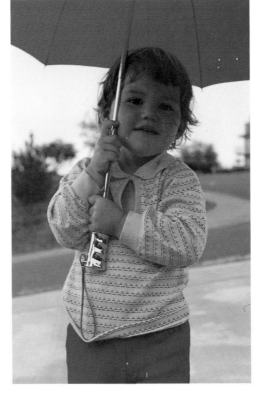

The photograph at top left is a good subject for a watercolor portrait. The features are well defined and there is a simple shadow pattern. Notice the beautiful warm glow of reflected light near the girl's chin. Best of all is the design potential created by the curved line of her jacket, repeated in the highlight in her hair, and again in the lock of hair that falls across her cheek.

Notice that the child's eyes in the photograph above are simple shapes in a dark area. This would, in my opinion, be a place where the eyes should only be suggested.

It would be difficult to paint from the charming photograph at far left. The children are beautiful, but there are no definite shadow shapes to aid in achieving a likeness.

This is a tempting photograph (left). However, the red glow on the girl's face, combined with the lack of definite shadows, makes this photo a questionable choice.

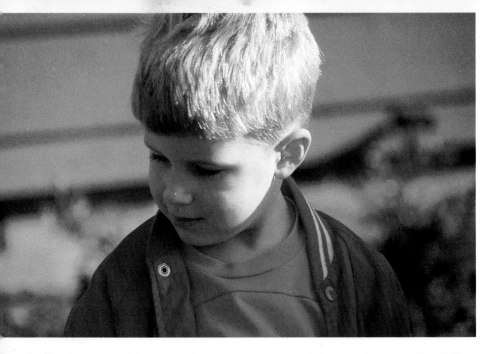

Either one of these photographs would be good painting material. The features are clearly visible, and the light and shadow areas are simple. Even though there is a minimum of reflected light, the boy's red jacket provides a wonderful excuse for inventing some reflected light on his cheek.

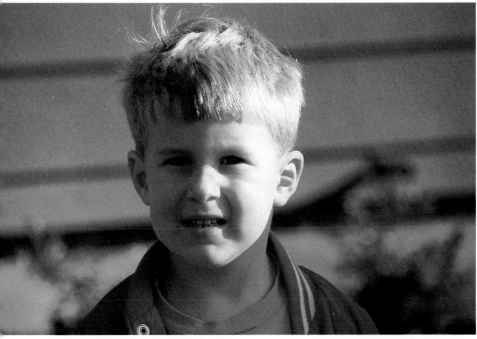

This is the one. As usual, I didn't find the subject, he found me. Doesn't this little guy look like a modern-day Huck Finn? I love that hair! The words I will write on the watercolor paper are "Watch out, Mom!"

What to Look For

Successful watercolors require advance planning. There is no time to make major decisions when the paint is running off the paper. You must know, at least in general, what you are going to do *before* you pick up the brush.

After you've made the decision about what to paint, it's time to enter into what I like to call the S.A.T. (stop and think) phase of painting. In portrait painting, this process begins with a critical observation of the model. By taking the time to *really look* at the model, it's possible to see things

you may have missed at first glance, and perhaps, prevent a few "I wish I had" complaints later on.

For instance, the way your model is lighted should be observed carefully. Take a look at the photo of Pat (page 79) that we have chosen.

The sunny side is clearly visible (A), as are the somewhat cooler areas turned slightly away from the direct sunlight (B). The shadow side is full of color. Let me show you what I mean. The cast shadow on the model's forehead (C) is dark just under her bangs,

becomes lighter, and then darker once more as it turns into the shadow side of her face (D), only to turn light again near her hairline (E). I see the color at her temple as being toward green. Follow the hairline down her cheek and the color seems to turn warmer, more toward orange (F) near her ear. That is the reflected light bouncing off her left shoulder. You can see that same glow of reflected light under the edge of her nose and under her chin (G and H).

Pat's hair can be described with

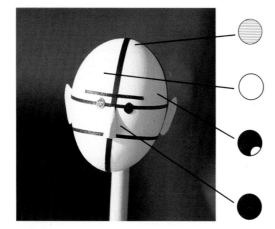

Let's start with what we already know. Here is Mr. E. H. again, pictured in much the same position as our model. This egg head will remind you of the simple separation of light and shadow, and of the basic laws concerning light.

This diagram shows how these simple shadow forms describe the head.

a great deal of color. It appears as greenish gold in the sunshine (**I**). The top of her hair is a cooler blue-green (**J**). This is in keeping with the laws of light that say all horizontal surfaces are cooler than vertical ones in full sun. Isn't that red glow at the back beautiful (**K**)?

How about the "underneath darks"? This warm color is to be found under her ear (**L**), in the corners of her mouth (**M**), and in several other dark recesses.

Study the folds in the sleeves. You will see shadows (**N**), cast shadows (**O**), and reflected light (**P**) appearing next to one another, creating a myriad of subtle color. There is more to see, so keep looking. (I'm aware that some of the color I'm describing may not all be visible in the illustrations here, given the limitations of the color printing process; however, a great variety of color *is* there to be seen in life. Interpret it the way *you* see it. You know where to look; it's up to you to find it.)

As you study Pat's face, try to think of "shapes"—the side of her nose, the curve of her cheek, etc.—as visible evidence of the underlying structure of the skull and the muscles over it. These shapes help identify a particular head, and are the basis for the modeling to follow. I like to include as much information about the location of these forms as I can on my sketches and suggest you put as little or as much as you find comfortable. There is no one way.

Later I will do an S.A.T. *sketch* in *watercolor* to incorporate many of the discoveries I made during this S.A.T. phase.

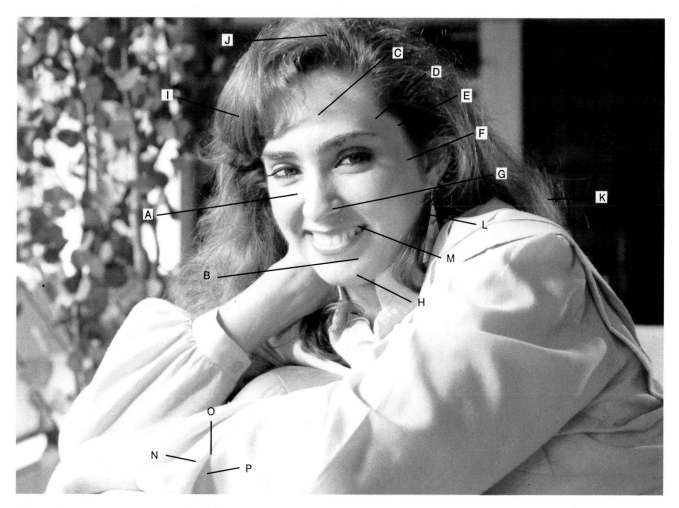

If you will study this photograph of my model, Pat, you'll be able to follow along with me as I describe my thinking process.

As you follow the step-by-step painting in the next chapters, refer back to this enlarged photograph to help you compare and identify the various light and shadow shapes found in her face.

Seeing Your Model

Now let's apply the same scrutiny to Jon-Marc. The various values and structural planes are easy to discern. Let's give him a closer look.

In the photograph on the next page, Jon-Marc's left cheek is in full sun (toward yellow orange). The front of his face is turned slightly and is considerably cooler in hue. Look above his left eye (A). This color is a cool red, and then becomes cooler still as it approaches the shadow side. You can see this cool red again under his left eye (B) and near his chin (C). The color temperature changes are clearly visible in Jon-Marc's hair. The direct sunlight adds sparkle, and then the color turns to gold approaching the shadow side. It then becomes almost cobalt blue on the horizontal area near the top of his head (D). These same changes in color "temperature" are visible on his neck near where the sunny and shadow sides meet (E).

Now let's look at the shadow side. We can expect to find reflected light along the jawline where the light bounces off his orange shirt (F) and at the bottom of his nose (G). Look at the beautiful reflected glow on his chest (H). The shadow side of his hair is full of color. Can you see blue, green, perhaps a bit of purple?

Last but not least, be sure to notice the reflected light under Jon-Marc's left ear (I). Ears are a very important part of any face and should be given careful attention.

A good portrait is the result of the decisions you make based on looking at your subject and really seeing. Once you've decided on painting from life or from a photograph, you must also ascertain what you're trying to convey about your subject. You must carefully observe the colors, values, and lighting and decide how they can be rendered to express your subject's personality. And finally, you must consider how to compose your portrait. In the next chapter, we'll learn how to apply the principles of design to create a pleasing composition.

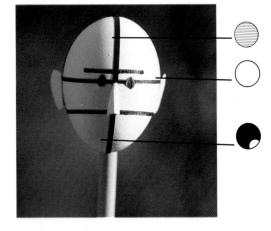

Mr. E. H. has obligingly posed once more. See how the line dividing the light and shadow areas aligns closely with the centerline of the features.

It's obvious from this diagram that once we render the shadow side of this young man's head properly, we've almost got it made.

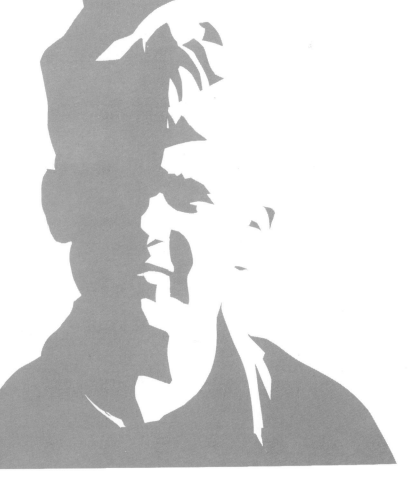

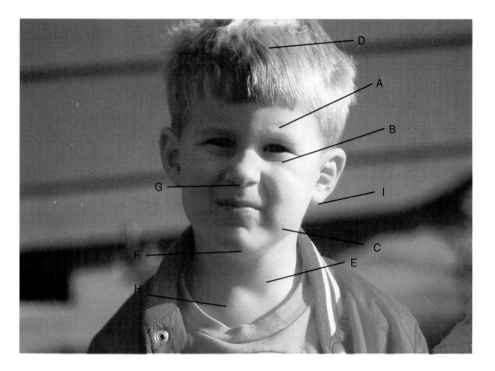

By studying the photograph you can discover all the colors in the light and shadow areas.

Once again, this enlarged photo will help you as you follow the detailed description of the painting process I used to create Jon-Marc's portrait in Chapter 6.

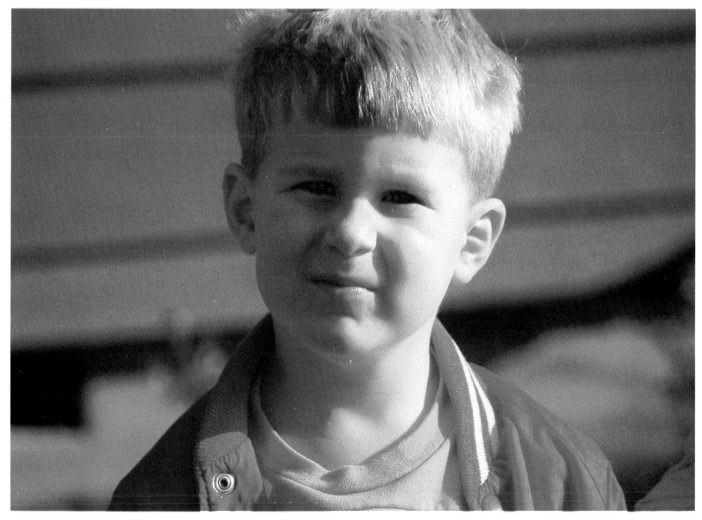

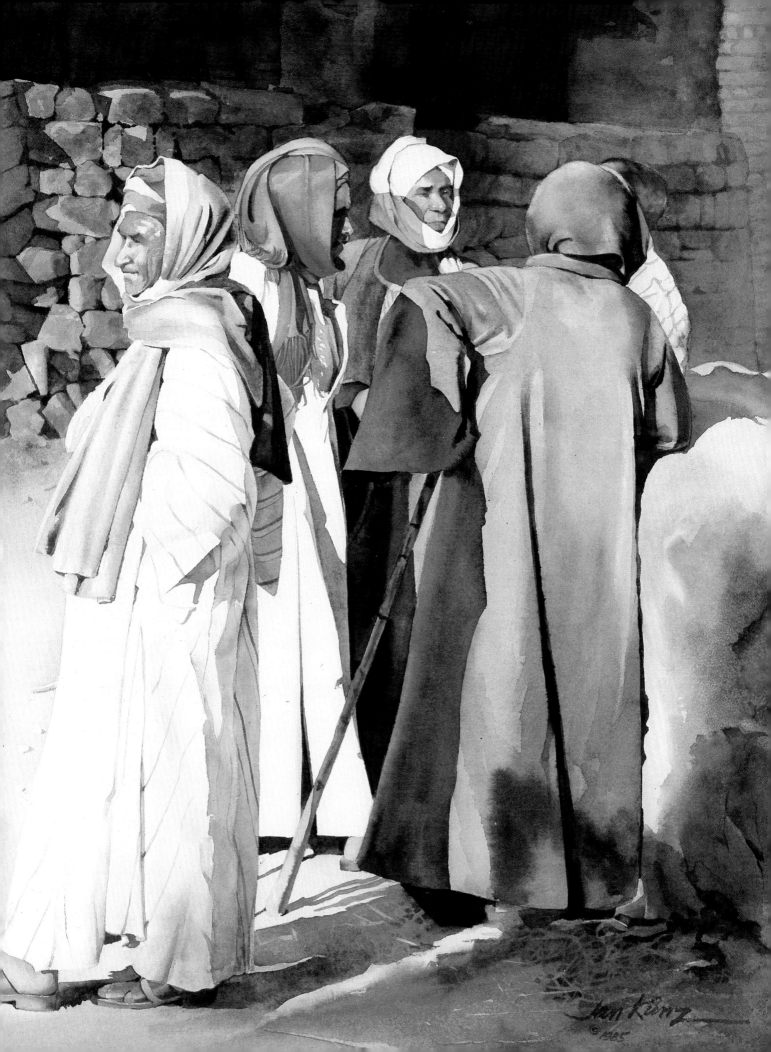

Composing the Portrait

Up to this point we have been concerned with the mechanics of painting a face. However, there will be times when you'll want to compose a painting with the face and figure in some sort of setting. Perhaps you'll want to show a child at play with some favorite toys, or a businessman at his desk. Composing a portrait presents the same design problems as does any other subject, and follows the same rules.

Before we begin to study what makes a good composition, let's talk a little bit about the elements and the principles of design. The elements of design are the materials or building blocks we use to create a composition. There are seven elements: line, texture, shape, direction, size, value, and color. The principles of design are the "blueprints" or methods of combining the elements when we build a composition. There are eight principles: repetition, harmony, contrast, gradation, alternation, balance, dominance, and unity.

When building a house we must make sure everything is united in one structure that is strong and stable. So, too, in portrait painting, we must strive to create a composition that is unified into a single strong image. The elements of design must be put together according to the principles of design. The result is a painting that is a safe and happy home for the viewer's eye.

Now let's look at how these ideas are applied to painting a well-composed portrait.

(left) "A Difference of Opinion" 18 x 25

A Pathway for the Eye

Successful composition is the result of creating a path for the viewer's eye to follow in the picture. Unity, dominance, and contrast can be used to make a trail that the eye can follow inside the boundaries of the picture's edge. Unity is the key. Unity is achieved when all the elements of an arrangement are subordinated to one plan. There should be one obvious route for the eye to follow, and one major idea for the viewer's mind to grasp. To paraphrase Edgar Whitney, you wouldn't put a rabbit's tail on an elephant, "... it's bad design." Your painting must be either a rabbit or an elephant all over.

To create a unified composition, some element has to dominate. There should be one center of interest, which should act as a magnet for the eye. If there are competing centers of interest, the viewer will be confused or disappointed. Contrast, such as a dramatic difference between light and dark or warm and cool colors, attracts the eye to a definite focal point. Contrast also entertains the eye once the viewer's attention has been attained. Study the following examples and trace for yourself the probable paths for the eye in each.

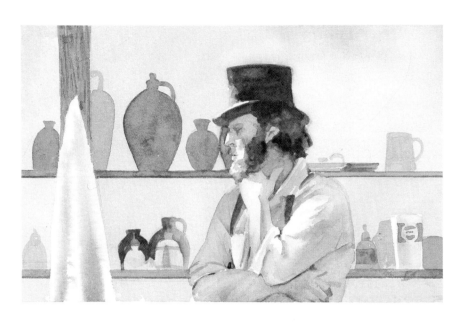

Bad:

The shelf intersects the model in such a way as to make his head appear to be a part of the pottery. The towel and soft drink cup are totally unrelated to the composition, destroying the unity of the picture by creating competing centers of interest.

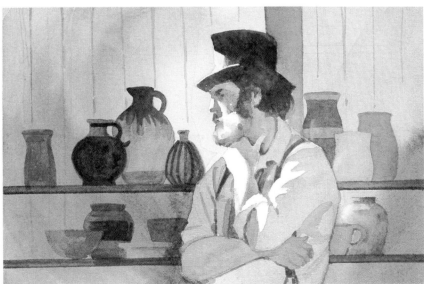

Better:

By lowering the shelf, organizing the pottery, and eliminating the unrelated objects, the model now becomes the center of interest. The shelves and upright also help direct the eye to the model, making him the focal point.

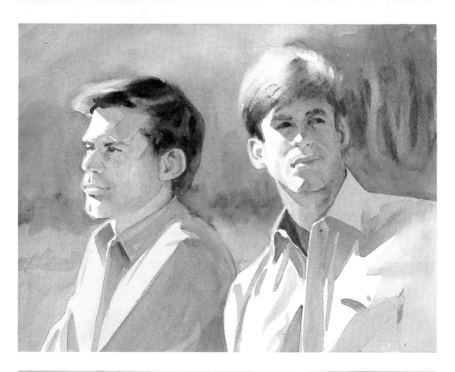

Bad:

The figures in the sketch fight for attention. Both appear to be looking out of the picture with the result the viewer's attention is drawn to the void between the heads, or out of the picture altogether.

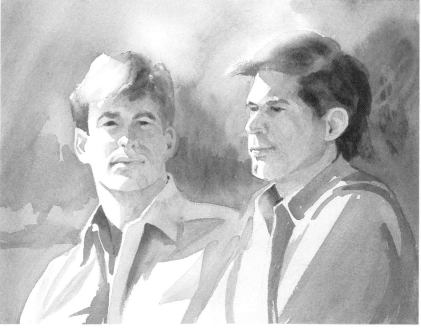

Better:

The composition is improved by rearranging the figures so they face into the picture area, keeping the eye from wandering toward the edge. However, neither face is dominant.

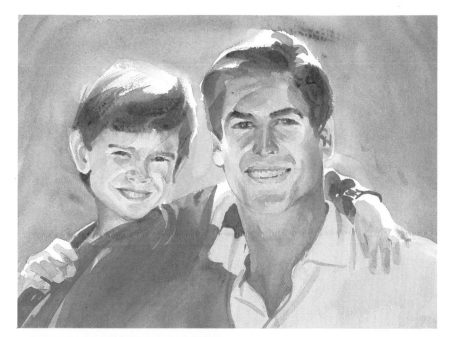

Best:

Compositions with two or more persons are generally more successful when the models interact with one another or are performing a joint action. Here, both subjects return the viewer's gaze, capturing attention and maintaining unity.

85

The Center of Interest

As we begin our venture into portrait painting, let's assume our first portrait will be a vignette. The first compositional decision to be made is where on the watercolor paper should we place our drawing?

For ages artists have studied rules of proportion for use in planning pictures. You may remember learning that the Greeks regarded the "Golden Rectangle" or "Golden Section" as the universal law of harmony of proportions in art and nature. The idea is to divide a line so that the shorter part is to the longer part as the longer part is to the whole. It works out to about 38 percent on one side of the line and about 62 percent on the other. According to this rule, the best place to establish the center of interest is where the vertical and horizontal lines cross. The diagram shows how the Golden Section points to the best position for the head in a horizontal composition. But if geometry leaves you cold, I have found a relatively safe rule of thumb when working with a vertical format. Mentally divide the picture area in half horizontally, and then into thirds vertically. Place the head anywhere the lines cross, as shown in the simplified grid overlaying the portrait below center.

In the following sketches the heads have been placed in ways that would make the portraits difficult to handle. An experienced painter can often get away with unorthodox arrangements, but for our purpose, let's keep it simple.

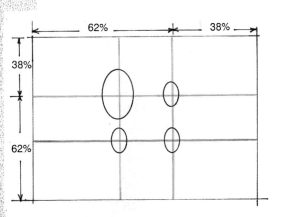

According to the theory of the "Golden Section," the best place to establish the center of interest in this rectangle is any one of the places where the lines intersect.

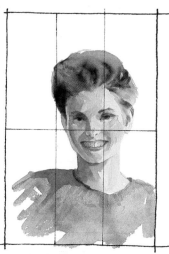

It is safe to place the head in approximately this position.

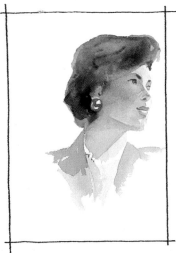

There is too much space behind this head. It's usually best to have the model's gaze directed toward the center of the composition.

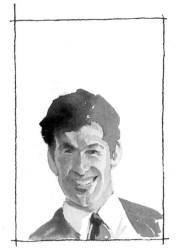

This head is placed too low in the picture area.

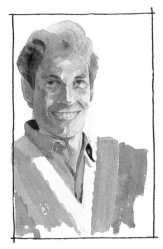

This head is located too close to the top and too far to the left.

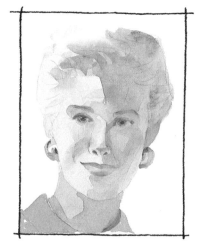

This head fills too much of the picture area.

The S.A.T. Sketch

Now for the S.A.T. (stop and think) sketch. This is one of the most important steps in my painting process. The S.A.T. sketch is the time to make important decisions about the painting I'm about to do. I stop and think about my observations and how I will place the figure in the composition, how my lights and darks are going to be arranged, the overall color scheme, and how all of this will express the mood and personality of my subject. Once I start painting, it will be too late to make these decisions. Making my S.A.T. sketch is when I do my visual thinking, not when things are happening too fast on the painting.

A few minutes spent in the last planning stage can serve you well. Keep in mind that the sketch should show enough to provide direction, but not be so inflexible that it interferes with a flash of insight. I agree with those who suggest that you think of the body as composed of simple geometric forms—the head is an ovoid, the arms and legs are cylinders, and so on. Before you commit yourself to something you may regret later, take a couple of minutes to do a stop-and-think sketch and plan your course of action.

At this stage in planning, several other important decisions are made. Above my sketch of Pat, I have written on my drawing board, "warm, approachable, friendly." That's the mood I want my painting to express. The warm colors are appropriate to the mood. The dominant shapes will be curved, with strong vertical and diagonal contrasts. All that's left is the actual painting.

At first I liked the way Pat looked when she assumed the pose you saw in the photograph on page 75. Her hair seems to disappear into the background color, and I like the idea of letting edges blend together wherever possible, but my S.A.T. sketch made me change my mind. It looks too heavy and forced. Another problem is that my eye wants to wander to the left side of the sketch—not good!

The second try is better. I eliminated the dark background, but left a "dark" (the edge of the wall) to act as a foil for her hair in the sunlight. Wrong again—that line seems to cut the sketch in half.

In this last sketch I decided to design the branches and leaves into a middle-value curvilinear pattern. I can make the real transition in value around the curve of her face.

Notice I did not locate the boundaries of the sketch. I use small mat corners to decide where I want the edges of my painting. I can move these corners about on my sketch and try several positions before committing myself to one.

Painting the Portrait

Painting is wonderful fun. With watercolor, the pigment seems to have a life of its own, and there are times when it seems like pure magic. Many of your painting decisions must be made on the spot, so try to be prepared for whatever might happen.

The best way to prepare is to have all the information you might need at hand. Plan your work the way it's comfortable for you. If you don't feel secure working the entire piece of water-color paper at one time—don't. If your preparation has been careful, you already have a well-thought-out plan for every part of your painting. It may not proceed exactly as you thought, but you can be sure your chances for success are increased many times over by careful planning.

You have seen my sketches, and you know I put anything and everything into them that I think might help me paint. A great deal of information on my sketches I may never use. It's like a security blanket. It may be of no real help, but I would rather have more information than I need, than to need it and not have it.

Have confidence in your own decisions. No teacher knows it all, and what's right for someone else may not be right for you. If you make a wrong decision you will soon know it. The point is to enjoy. There is no hurry, and even if (heaven forbid) *everything* goes wrong, there's still the back of the paper to use.

(right) "Mountain Man" 13½ x 20½

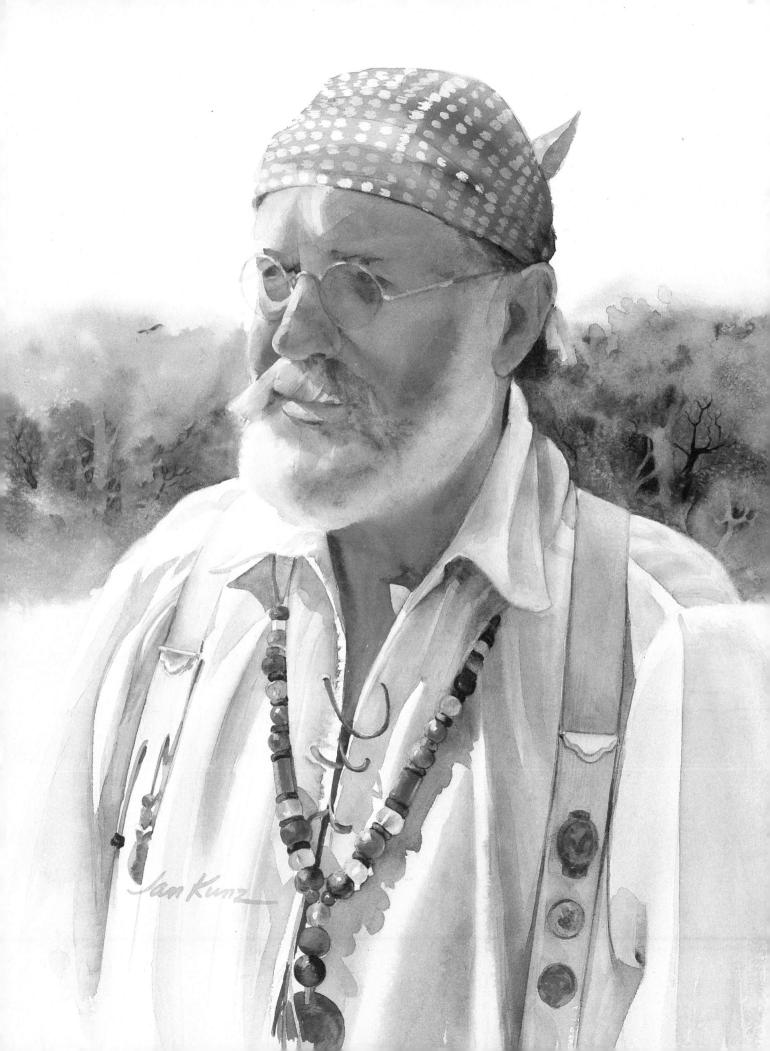

The Final Drawing: Jon-Marc

I want to present Jon-Marc as a vignette. There's nothing formal about Jon, he's just fun and I want to present him in a very casual manner. Working from the photograph I had selected, shown on page 81, I developed an accurate and informative final sketch.

Here's an easy way to re-check your final drawing if you have any doubts about its accuracy. Place a clean piece of tracing paper over the face you have drawn, and trace the facial ovoid. Draw a center line and mark the features where you have placed them, using spheres for the eyes, and a wedge shape for the nose. Then remove the tracing paper and look at what you have just drawn. Any mistake you've made will be easy to see on this simplified version of your drawing of the head. For instance, you may find in re-checking that the eyes are not located halfway down the facial ovoid. Whatever the problem, you'll find it easier to correct once you know where to look.

As with every portrait, the first concern is to decide on the size of the head and then to draw an ovoid accordingly. The next step is to locate the features. I find it easier to establish the location of these guidelines by marking their approximate position to the side. You can see the marks next to the head I have drawn at right.

Using a clean piece of tracing paper (far right), I spot in the nose, eyeballs, and hairline. The location of Jon-Marc's features conform to the norm, so there is very little adjustment to be made.

On this overlay (right), I study the shape of Jon-Marc's eyes, and draw the lids "over" the eyeballs. I want to become familiar with his turned-up nose and the way he smiles with the corners of his lips turned downward. Next I draw some of the clothing.

On another overlay (far right), I get down to the nitty-gritty of locating the shadows and adding all the detail I want. Here's my final sketch. The drawing is ready to be traced onto the watercolor paper.

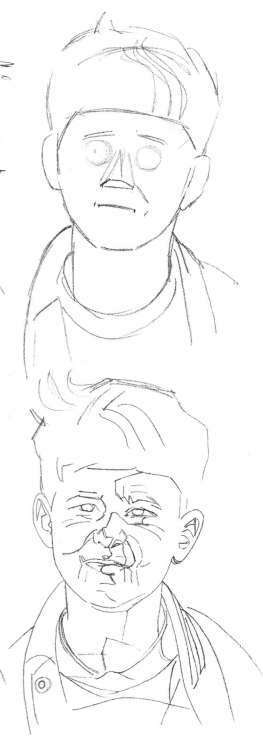

Applying Color: Jon-Marc

This is where it all comes together. It's exciting to see the clean, taut sheet of watercolor paper with the drawing in place, just awaiting color.

We are ready to put into practice what we've been discussing. In essence, it's possible to paint watercolors that glow by remembering four things:

1. Adhere to the 40 percent rule when painting the shadow side.

2. Add reflected light wherever possible.
3. Never use complementary mixtures in values darker than 6.
4. Use pure color and permit it to blend on the paper rather than on the palette.

I will use new gamboge and cadmium red to describe Jon's fair complexion. Cadmium red is slightly warmer than Winsor red, the other possible choice.

Let's paint Jon-Marc together. In this exercise you may want to draw him yourself, or trace the drawing in the back of the book (page 140). I will paint him in five separate steps, and you'll see that even though I begin each step with the same pigments, any number of combinations can result from their mixing on the paper.

Step 1

In this first step, use a mixture of cadmium red and new gamboge to block in the basic flesh color. The value should be light—between 1 and 2. There's no black in either of these pigments, so you're assured of a clear bright color.

Load your brush with a good amount of this mixture and paint it over the entire face and neck. Then immediately wash out your brush in clean water and moisten the hair area. Now add a light value new gamboge to suggest the hair in sunlight. Don't cover the entire wet area with pigment—just drop a small amount into the middle and let the water carry the color. If some of the yellow flows into the flesh color, don't worry. We want a soft edge at the forehead, and any error can be corrected later.

You may want to use some more new gamboge, or perhaps cadmium orange, to suggest the color of his shirt. This is a good time to do it, but stay away from the face and hair until they are thoroughly dry.

Step 2

Now for some excitement. We know where the shadows on the face are located from our careful final drawing. Let's look again to be sure we know exactly where the shadow edges are located and which edges we want to make hard, and which ones should be soft. You may want to take your pencil and refresh some of your guidelines.

After we're sure of what we're going to do, let's mix two puddles of pigment: one of sap green and raw sienna, and another of alizarin crimson and burnt sienna. Use a scrap piece of watercolor paper to test the value of each of these mixtures. Remember, these colors must be dry when you evaluate them, and they must be 40-percent darker than the initial wash.

Have two brushes ready (I would probably use number 5 or 6 round brushes), one for each of the mixtures. Start above the hairline with the green mixture and bring your brush boldly down into the area of his right eye, across the nose, and into his left eye. Immediately switch to the other brush and bring the warm color into the forehead and down the center of the cheek.

Now dip a clean brush into the new gamboge. Be careful not to get the yellow too intense. Draw this color along the jawline and under the chin, letting it combine with the red mixture. Before this shadow side is dry, use the red mixture to paint the ear and the neck. Okay, we can breathe now!

Let's survey what we've done. You can see that I got into some green with the new gamboge, but I'm not going to let that worry me because it'll all be worked out in the next phase of painting. You probably have some dry hard edges that you wish were soft. That's okay, too. Here again, if necessary, we can make corrections later. The point is, we have been bold. We are in command! Sometimes the watercolor pigments don't listen, but this looks fine. To paint the shadow side, and the cast shadow on his

other cheek (A), we use new gamboge nearest the mouth, with cadmium red alongside. Let's soften the edge with a moist brush. Now we can put the darks into the ear.

Notice that in order to suggest reflected light on the jacket, I use new gamboge, then an intense cadmium red laid alongside (B), much the same as in the cheek.

Caution: Even if you're not completely satisfied with your shadow side, *do not* try to fix it now. The paint is no doubt only half dry, and any fussing now will only result in an unlovely blob. Let everything dry, and then we can attend to corrections.

Step 3

This part is really fun because now we're going to model the face in sunshine. Of course, it's impossible to model only a part of the face at one time—you're going to want to carry a brushstroke into the shadow side—but at least we can start on the sunny side.

Let's consider the parts of the face that are turned slightly away from the direct light. From our understanding of the laws of light, we know these areas will be cooler than the sunny side, so we must paint them that way, even if this coolness isn't very apparent in the photograph.

After washing the palette (which has become a real mess) and filling the container with clean water, we can use a light- to middle-value mixture of alizarin crimson and burnt sienna to model and cool facial areas. Try to let your brush follow the facial contours (A). You may want to begin with a brush loaded with pigment, then add water as the stroke advances. Notice that I add the cast shadow on Jon-Marc's left cheek at this time (B). Now we can paint more color into the hair, remembering that the color must become cooler as it approaches the shadow side.

There are still some edges that I don't like, but let's continue. If we make all the corrections at the last, we won't have any damaged paper to contend with during the painting process.

A

B

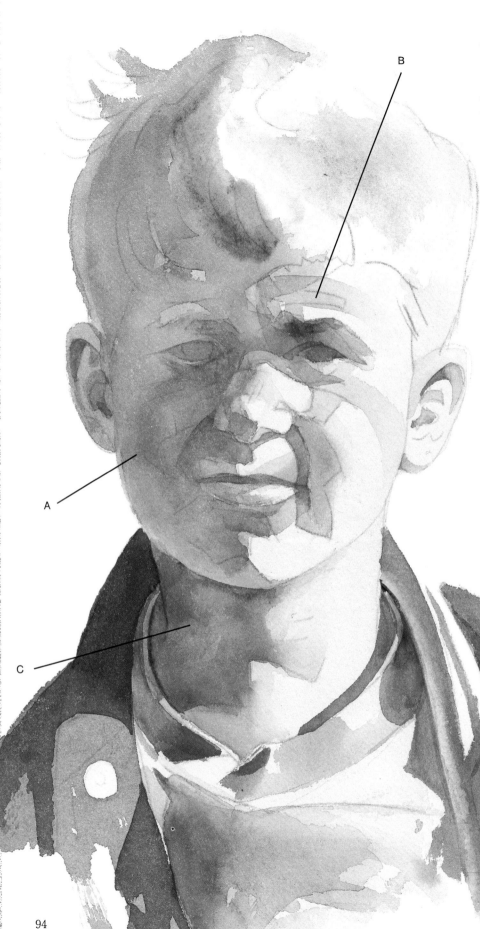

B

A

C

Step 4

Let's do our modeling in the shadow side. I want to make Jon-Marc's cheek a healthy color. It's too green for my liking, so I wet the whole cheek area and then, using a brush loaded with cadmium red dark and little water, I paint a line right down the middle (A). Cadmium red, as you remember from our pigment chart, is an opaque precipitate. This pigment will lie on the surface and not disturb the color underneath, so it does just what I want it to do—brighten a dull area.

Notice that some of the modeling starts on the shadow side and is carried into the sunny side (B). As you become more familiar with this method of painting, you will be able to handle this step and the previous one almost simultaneously.

Here you can see that the darker colors in the neck area (C) heighten the effect of the reflected light on his chin. Let's bring the clothing to a finish, and survey our work.

Step 5

Now we can add the final darks and detail. It's also time to take whatever corrective measures seem needed.

Let's finish the eyes and eyebrows. Slightly moisten the eyebrow area with clear water. Then get a rather thick blob of raw sienna on the tip of a small brush. Deliberately daub the brush tip where you want the brow to appear darkest. You may want to add other colors as you draw out the brushstroke along the brow line, the choice is yours.

Next we can add the eyeballs. It's nice to let this little guy look back at us. I use a dark purple combination of alizarin crimson and Winsor blue, and then complete his eyes with a touch of pure alizarin at the corners.

Now for the corrections. Use a slightly moistened, stiff bristle brush, like the brushes oil painters use, to soften any edges that may look too hard. I use such a brush to soften the edge of the green color under his left eye, and along the edge of his jawline.

One final tip: If for any reason you're not happy with your painting, try painting over the entire face (once it's dry) with clear, clean water. This tends to soften all the edges and unify the head. If this doesn't work to your satisfaction, try mixing a very light-value puddle of cobalt blue with a touch of alizarin crimson. Be sure this is a clean mixture with no other pigments added. Then paint this mixture over the entire shadow side, using light brushstrokes so as not to disturb the pigment beneath. This will serve to subdue too severe contrasts and further unify the shadow side.

The Final Drawing: Pat

My portrait of Pat was done from life. The photo on page 79 shows her in the pose I liked the best. A horizontal format works well with this pose and fits neatly on a half sheet (15" x 22") of watercolor paper, with the head about 5 to 6 inches in height.

I use the same process preparing the final drawing of Pat as I did for Jon-Marc. I begin by establishing the general position and the swing of the body using simple geometric forms just as I did on the S.A.T. sketch (see Chapter 5).

On a clean sheet of tracing paper overlaying the first, I begin to delineate the features. The lines are very generalized at first, and then refined with more overlays. Here you see overlay number three. I want to establish the folds in her sleeve before taking my sketch any further.

Full attention to finding the planes and shadow areas on her face comes next. This is all the information I need, but I decide to take the sketch one step further.

In this final refinement, I locate her teeth and the earring. Should any unforeseen problems arise, Pat's smiling face is there before me.

Applying Color: Pat

Before we begin to paint, a word about brushes. As I pointed out earlier in the book, I like to use brushes that are appropriate to the size of the area to be painted. Just as you would not paint the side of a house with a watercolor brush, so it is important to use a brush large enough for the area to be covered. When painting a face, I usually use a no. 10 round brush for the skin tones and hair (remember, these heads are usually 6 to 8 inches high). As I work into smaller areas I switch to a smaller brush. Most of the detail is done with a no. 6. For very small crevices around the mouth or in the eyes, I may choose a brush as small as a no. 3. For background areas I rely on my 1-inch Aquarelle most of the time. Be careful not to select a brush that's too small. The use of a small brush can result in a "picked over," fussy look.

It's important to remember to clean your brush before you add each new color. I often use two brushes, especially when I'm working two colors and want them to mix on the paper. In this way I can work fast into a wet area with the assurance that the colors are not being neutralized on my palette.

Now that we're all warmed up, let's start to work on Pat's portrait.

Step 1

The skin color is a mixture of cadmium red and new gamboge. When dry, the value is almost 2. After her face, neck, and wrists are painted, I give her shirt a light wash of rose madder alizarin. Any other rosy hue, such as a light value of alizarin crimson or Winsor red, would serve as well. (I stay away from rose madder genuine. That pigment has a way of lifting with the addition of subsequent washes.)

While these colors dry, I wet the area behind her hair with clear water and drop in brushloads of the skin color and then that of the blouse. Let the entire painting dry before proceeding with the next step.

Step 2

I mix one puddle of sap green and new gamboge, and another of burnt sienna and alizarin crimson, checking to be sure each of these mixtures is close to value 6 (when dry).

Beginning at Pat's hairline, I draw the alizarin mixture across her forehead into the temple. Then, quickly switching to the other brush, which is loaded with yellow green, I bring that color into her left eye (A). Returning to the first brush, I continue the warm color down into her cheek. Next I run a line of cadmium orange along her jaw, letting the

color combine with the red mixture to suggest reflected light (B). After the entire shadow side is complete, I use a brush moistened in clear water to soften the edges wherever needed. If the edges are too dry to correct in this way, it's best to wait until the painting is near completion and make such corrections with a bristle brush.

Cadmium orange is very opaque, and since it should blend smoothly with the red mixture, use enough water to permit the heavy pigment to flow freely.

To paint the shadow side of Pat's wrists, I use a fairly wet brushstroke of new gamboge along the bottom, and immediately add the alizarin mixture, softening the edge as the shadow approaches the light.

Now the background gets another coat. Once again moistening the entire area with clear water, I use just the tip of my brush to drop color into the wet area (C). The soft-edged dots of color are intended to suggest leaves later in the finished painting. Everything must dry before the next step.

Step 3

Since there is very little modeling to be done on the sunny side, I begin shaping both sides at one time. On a clean palette, I mix a middle-value purple (alizarin crimson and ultramarine blue) to darken her temple, upper eyelids, and the corners of her eyes. This same color serves to accent the shadow from her eyelashes that falls across her cheek and then continues into her hairline (A). The modeling on the sunny side is accomplished with a mixture of cadmium red and new gamboge.

Notice the folds in her shirt sleeves. I first moisten the area and add new gamboge to suggest reflected light, then immediately run a fairly thick line of rose madder alizarin along one edge (B). The shadow will be completed in the next step.

Moisten the entire background one more time with clear water and add more color.

Step 4

Here you can see the modeling phase of the painting as it progresses. I add darks into the corners of her mouth and begin to model her hair. I like to paint hair by adding one pure color at a time and letting them mix on the paper. The painting goes much slower now as details and darks are added.

Step 5

There is a myraid of color blobs in the background. These shapes can be used to create visual entertainment as well as provide the opportunity to repeat the dominant rounded forms. I add a few vertical shapes to create contrast.

After everything is thoroughly dry, I study these shapes. There are places that *could* be the edges of leaves, or perhaps a branch in the making (A and B). I use my brush loaded with a darker color to paint around the blobs that I want to develop into leaves. I don't want to paint every leaf or branch, just enough to suggest their presence. The viewer can imagine the rest for himself.

A

B

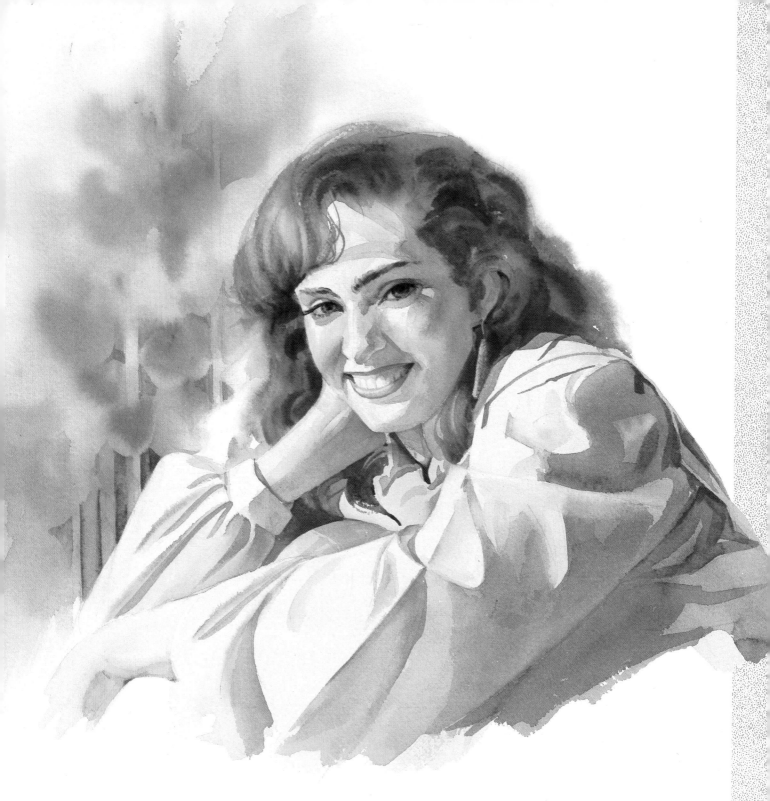

Step 6

Painting the background is fun, but now this area seems to demand too much attention. To correct this problem, I decide to glaze over the entire background with a light wash of cobalt blue, avoiding Pat's hair and being careful to keep the edges soft. Whenever you use cobalt blue in washes, it's a good idea to use fresh pigment. When cobalt blue becomes dry in the palette, it has a tendency to break up into hard little chunks. The last thing we need here is an unexplained streak of blue across the background.

The shadow side of the sleeve is painted last. I decide to use a warm reflected light on the bottom edge. I know it appears quite green in the photograph, but green would appear cool and neutralize the rosy color of the blouse. Yellow, on the other hand, adds glow and is in keeping with the mood of the painting.

Here is Pat's portrait. Her smile and the harmonious colors and shapes all say, "Warm, approachable, friendly."

3.

Portrait
Studies

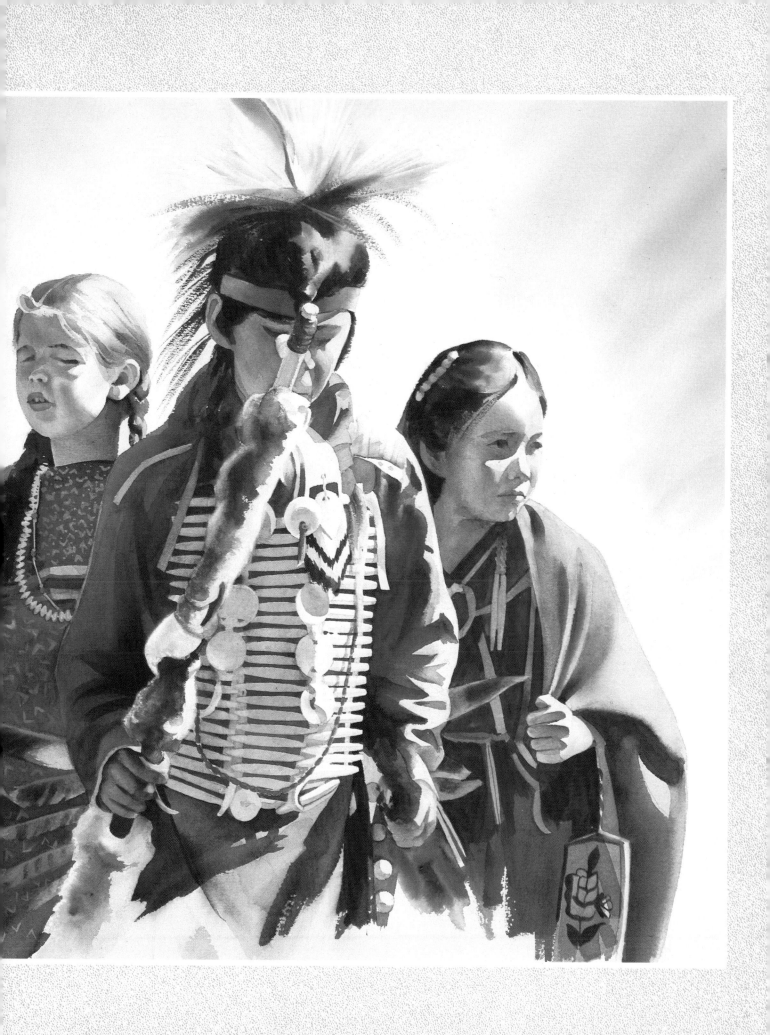

Demonstration
Young Black Man

This good-looking young man's name is Lamb. He looks serious and determined. The first thing I noticed about him is the direct way he looks at you. I will try to suggest his straightforward, confident personality in my painting.

As I study this face, it becomes apparent that I could logically include blue reflected light on the shadow side along his cheek. I see no light actually bouncing off of his blue-black sweater. However, because it *could* be there, I can force a color accent and still not disturb my viewer's eye. On the contrary, such color would add interest and brilliance to my painting. The shadow pattern on his face is relatively simple, so this would make a good practice portrait.

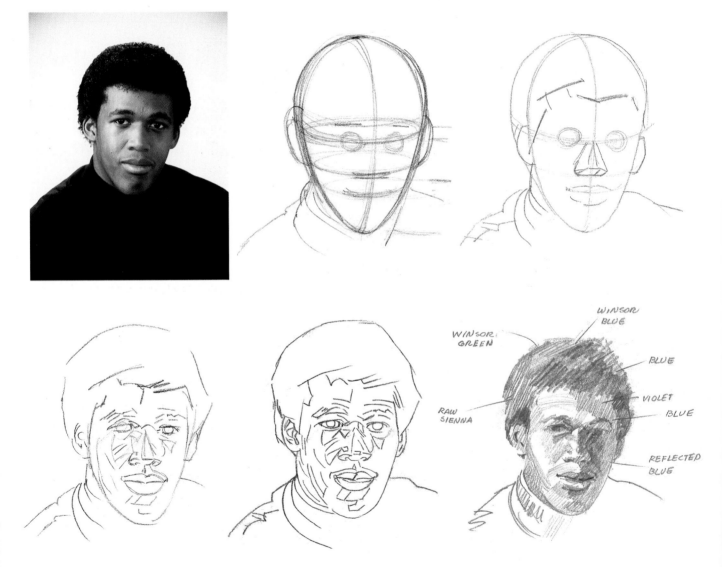

As usual, I developed the preparatory drawings based on the photo using tracing paper overlays. I also jotted down color notes on my original pencil sketch (bottom right).

Step 1

After the final drawing is transferred to the watercolor paper, I paint the skin color a warm mixture of cadmium red and raw sienna. The value is 2.

Step 2

It's time to paint the shadow side when the first wash is dry. I have had students worry that the value of the shadow side (6) appears too dark. I tell them to be bold and paint it anyway—they won't be sorry.

The first shadow mixture is ultramarine blue and alizarin crimson. After making sure the value is 6, I begin in his forehead and paint down to the bridge of his nose. Then, before the paint can dry, I use a brush moistened in clear water to soften the edge over his eye. Next (here comes that reflected light), I dip into Winsor blue and permit that color to combine with the violet at his temple. I complete the rest of the shadow side using these colors.

Now I wet the hair area and drop in pure color—raw sienna to suggest sunlight, then a cooler Winsor green, and finally Winsor blue into the shadow side. Some of this blue floods down into the shadow side of his face.

Step 3

Modeling the sunny side is next. Notice the cool color on his jawline just under his right ear. I paint this area with a light violet to suggest his beard. The modeling on his cheek and on the top of his nose is accomplished with a mixture of alizarin crimson and burnt sienna. These colors accent the portions of his face that are turned slightly away from direct light and are therefore somewhat cooler than the side of his nose and cheek.

Step 4

The pace is much slower now. I take the time to study the facial planes and be sure my brush follows their contours. Using darker values, and making adjustments along the way, I can see Lamb's face take shape.

Step 5

Looking at his right eyebrow, I notice that the portion nearest his right temple is lighter and perhaps bluer than directly above his eye. His left brow also appears to have some reflected light in the temple area. To paint his brow line, I dampen the area with clear water and daub pure Winsor blue into the darkest portion. Before this can dry, I add burnt sienna over the Winsor blue to add color and warmth.

I finish the portrait using various combinations of the same colors as those used throughout.

After the painting is complete, I erase the pencil lines and make any corrections, such as softening edges or lifting highlights.

Demonstration
Little Girl

This little girl's name is July, and she looks as sunny as her name. I made several sketches of July on a Sunday afternoon as she was playing near a wading pool. I noticed her hair glistened in the sunlight and was very close in value to her skin. I wanted to paint this child who looks like a bouncing sunbeam.

This portrait is more difficult than some we have attempted because the shadow area is large and there is a great variety of color. This might be a good place to simplify the shadow color and concentrate on value. We'll find it easier if we break the painting procedure into small, manageable steps.

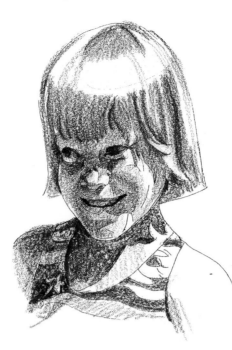
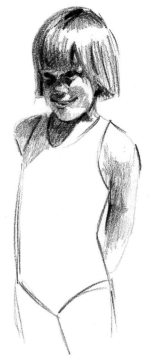

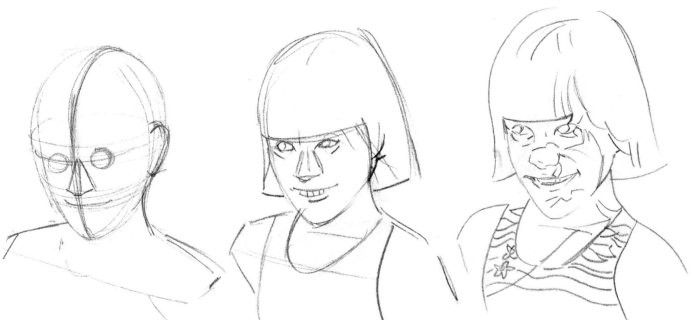

In my sketch, I paid close attention to the pattern of light and shadow on July's face, then I developed the final drawing in the steps shown above.

108

Step 1

We begin with an initial wash of new gamboge and Winsor red. Without waiting for this to dry, add a dilute wash of new gamboge into her hair and let the color blend with the flesh color at her forehead. Then add water to fade out the yellow wash as it approaches the crown.

Step 2

Before we attempt the shadow side, let's get everything prepared for some fast action. We can paint this side in several steps, but we will want to work fast so the edges won't dry between the addition of various colors. First we must mix two puddles of pigment. One puddle is a combination of new gamboge and sap green. The other is alizarin crimson and burnt sienna (heavy on the burnt sienna). After we have tested these colors for value, we should have at the ready three clean brushes—nos. 5 or 6—and a good supply of fresh colors.

First, with clear water, let's slightly moisten July's hair just above her forehead. Now we can place a bold stroke of cerulean blue across the top of her head, and quickly add (in this moistened area) alizarin crimson, raw sienna, and burnt sienna alongside the blue. It's important to wash out your brush (or use a clean one) between each addition of color.

Before any of this can dry, we dip into the sap green mixture and brush along the forehead and into the eyes. Use a clean brush to continue with the alizarin mixture, painting across the bridge of her nose and under the eyes. Next comes new gamboge along her right cheek, and finally back to the red mixture to finish the chin.

Let's stop and assess the work before completing the shadow side. So far we have added each color separately and permitted them to mix on the paper—the effect is brilliant and exciting (even though it may be a bit frazzling on the nerves).

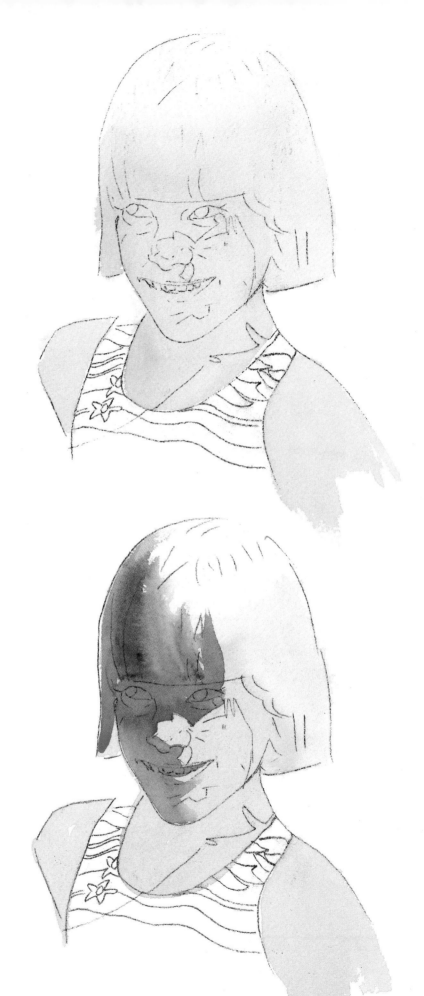

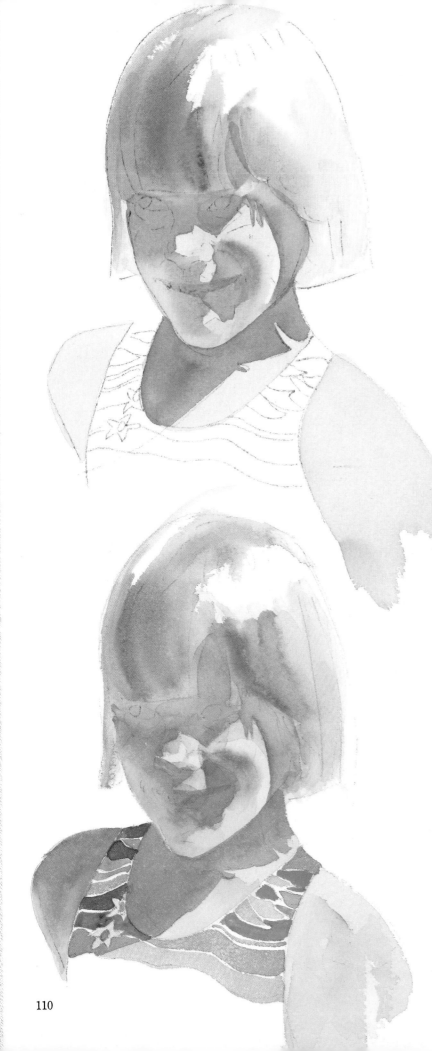

Step 3

After the right side of July's face is dry, we can go at a slower pace to complete the shadow side.

Let's wet her left cheek with clear water, then gathering a rather thick glob of cadmium red deep onto the tip of a brush, draw the curve of the cheek into the wet area. Immediately follow with a stroke of new gamboge and let the two colors blend as we draw them down across her upper lip. We will have to darken the shadow on her upper lip after the present wash dries because a cast shadow is somewhat darker than the shadow side. The shadow on her lower lip and chin is a combination of alizarin crimson and ultramarine blue. We can also add the cast shadow on her left cheek using the alizarin crimson/ burnt sienna mixture. The shadow on her neck and chest comes last. Notice that I start this shadow with a cooler mixture of alizarin crimson and ultramarine blue, and then add more alizarin crimson and burnt sienna as the shadow approaches her shoulder.

Step 4

July's right shoulder is a mixture of new gamboge, alizarin crimson, burnt sienna, and ultramarine blue, permitted to mix on the paper.

There's very little modeling to be done on the sunny side of July's face. The top of her nose and the bottom of her cheek are turned slightly away from direct light, so we must cool the color in that area. It's fun to add some brilliant color to her bathing suit—anything goes!

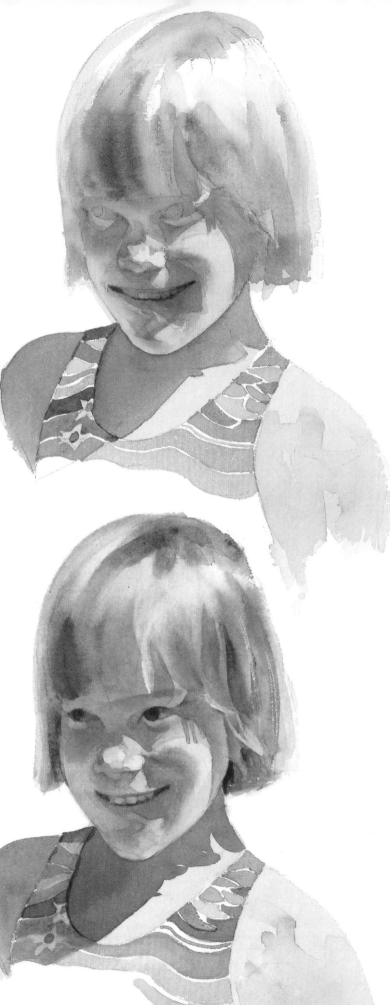

Step 5

Now we must go slower and think about modeling the facial planes. The cast shadow on her upper lip must be darkened and her eyes need defining. The warm crevice darks in her mouth are alizarin crimson and burnt sienna. We can get the best results by first applying color to the corners of the mouth and then carefully painting around the teeth. After the color has dried, draw a brush moistened in clear water from the corners of the mouth toward the center — the pigment will lift just enough to darken the teeth near the corners, and give the illusion of roundness.

Step 6

This is the fun phase of painting. All that remains is to add darks and make any necessary corrections. I use my acetate frisket and a stiff brush to lift some color in her hair and to add a white highlight to the tip of her nose.

Here is July, warm and sunny as the month after which she was named!

111

Demonstration
Young Boy

In this demonstration I worked from a snapshot of a handsome young man named Greg. The photograph was taken in the shade with only a suggestion of the shadows on his face. It's far easier to get a likeness if you can see the shadows clearly. But failing that, the next best thing is to carefully draw the head and locate the shadow areas as I did in my S.A.T. (stop and think) sketch.

Here are a few suggestions if your model does not have strong shadows. Study the face carefully; it may be possible to locate a hint of shadow. If you're not using a model, or if you can see no trace of shadow, find a photograph where the shadows fall where you have in mind. If all else fails, study your own face in a mirror. Stand in the light so the shadow falls on your face in much the same way

as you want the shadow to appear on your model.

Now back to the model you are painting. Draw the facial outline on your sketch paper and block in the shadows (I like to do this on a tracing paper overlay) as they appear on your surrogate model. It's easier than you may think to create a convincing shadow side.

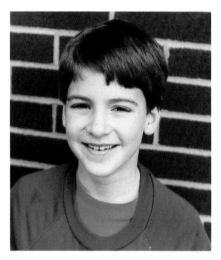

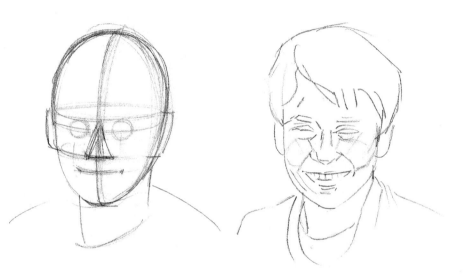

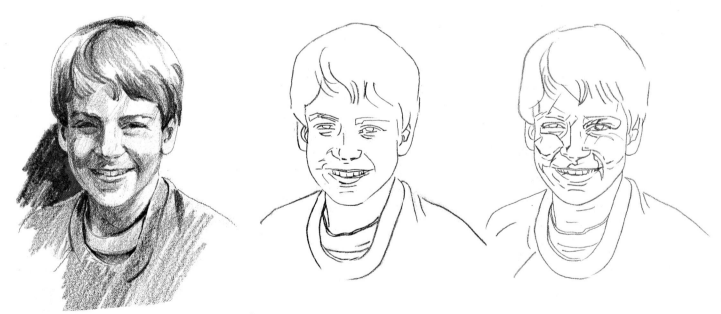

Since the shadows are indistinct in the photo, I spent extra time locating them on my sketch and preliminary drawings.

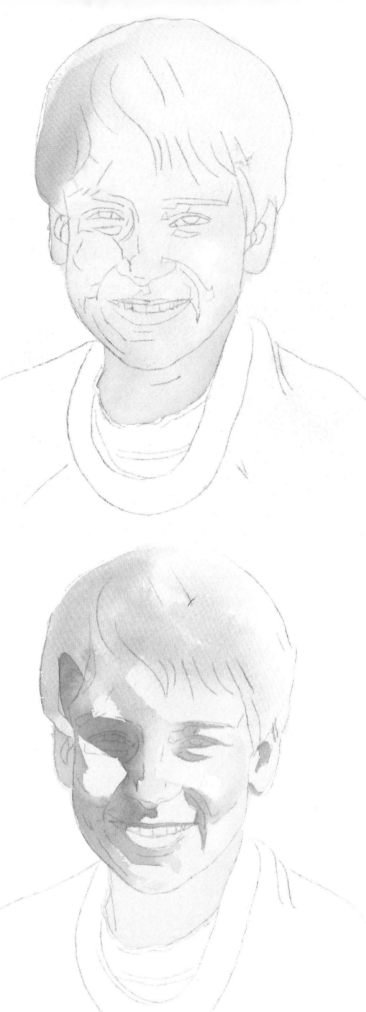

Step 1

The painting process begins with a wash of new gamboge combined with Winsor red. I use a no. 10 round brush and enough water to keep the surface somewhat fluid. Quickly I add a dilute mixture of new gamboge and sap green into the area of the hair, and let the color blend at the forehead. There is a small white (unpainted) highlight in his cheek. I'll decide later if it should remain.

Step 2

Now for the shadow side. I want to keep the area around the eyes cool, and blend the color into a near red around the nose and mouth. To do this, I mix in my palette a grayed green, using sap green and cadmium red. This is a safe combination in light values (remember, complementary mixtures in values darker than 6 equal *mud*). The skin color is at value 1, therefore this gray-green need only be at value 5.

Next I mix another puddle of alizarin crimson and burnt sienna, and still a third of alizarin crimson and Winsor blue. After all the colors have been tested for value, I get out my three trusty no. 6 brushes and load each with one of these mixes.

With the S.A.T. sketch for a guide, I use the brush dipped into the purple mix and begin at the hairline, drawing the color down into his right eye. Quickly switching to the green brush I continue to his nose. I use the red brush to complete the shadow shape. Before any of this has had a chance to dry, I dip into new gamboge and drop this brilliant color along the jawline and at the tip of the nose to suggest reflected light. The left eye gets a splash of green. By rinsing out my brush with clear water, I can use it to dip into the still-wet pigment (on the paper) and pull a lighter value of this green across the brow to suggest the indentation that is almost always present between the eyes.

Step 3

Now it's time to begin modeling in earnest. Beginning with the sunlit side, I add color to his cheek. The areas that are somewhat turned away from the direct light receive a cooler blue-red. My colors are alizarin crimson, burnt sienna, and cadmium red.

I use various combinations of alizarin crimson, Winsor blue, and burnt sienna to model the shadow side.

The shirt will be painted blue, so I add blue to the neck to suggest sunlight bouncing off the inside of the collar.

Step 4

There is a lot of color in Greg's dark hair. This is an opportunity to be bold and add brilliance to the painting. Following the contour of his head, I add pure color, laying one brushstroke at a time next to another and permitting the color to combine freely on the paper. This is when watercolor is really exciting—it almost paints itself!

Since the colors on the snapshot are pale, it's easy to make the mistake of painting the shadow side in too light a value. This requires checking the value scale frequently to make sure the shadows are dark enough.

Step 5

In this last phase, as in the previous one, I add the final darks at the corners of the mouth and in the shadows on his neck. The colors for all such darks are usually a combination of alizarin crimson and burnt umber.

After painting the clothing, I introduce some background color to help distinguish the edge of Greg's cheek. Finally, I use my small, stiff, oil-painter's brush that has been slightly moistened to soften any edges that might require a little help. That little white highlight on his cheek is still there, but it's almost unnoticeable.

My first reaction upon looking at this handsome young man was, "This is a nice person." The twinkle in his eye and that big grin tell you he is warm and caring. I would also wager that he's full of mischief! Anyway, shadows or no, Greg is a great model.

115

Demonstration
Elderly Lady

This lady's name is Sarah. She was seated in front of a warm fire when I sketched her. The light coming from below made her face glow and lit up her sparkling black eyes. In this subdued light it was easy to imagine Sarah as the beautiful young woman she once was.

To avoid the possibility of her features emerging almost ghost-like from a dark background, I decide to add the glow of reflected light to the left side of her face.

Here is the sketch, right, and it is the basis for the demonstration to follow. Sarah lives only in my memory.

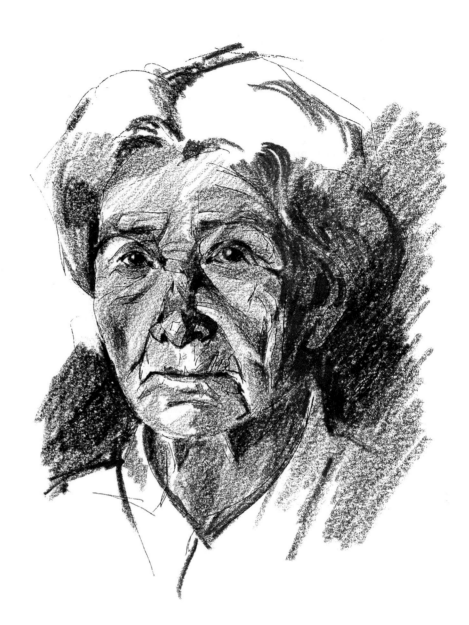

Sarah's face revealed a great deal of character, which I attempted to retain in my preliminary drawings.

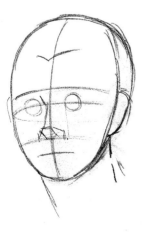

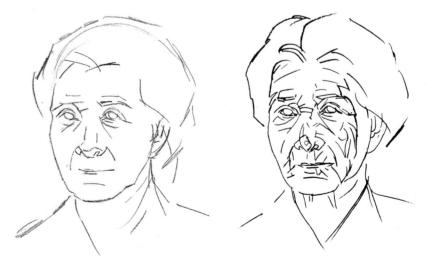

116

Step 1

After tracing the drawing onto the watercolor paper, I apply a light value mixture of alizarin crimson and new gamboge with a 1/2-inch Aquarelle brush over the entire face and into the hairline. Before this wash can dry, I add a dilute solution of Winsor blue into the area of the hair and permit it to blend at the edge of the face.

Step 2

Now for the shadows and the glow on her left cheek. While this first wash is drying, I wipe my palette clean and mix two puddles of pigment. The first is a cool yellow-green using new gamboge and sap green. The other is a violet mixture of alizarin crimson and Winsor blue. The violet mixture should be slightly darker than value 4.

Beginning with the green mixture, I use my no. 6 round brush to draw a line of color along the outer edge of Sarah's left cheek. Quickly switching to the violet mixture I run this color alongside the green and permit it to mix on the paper, then continue to paint the shadow forms. In several places I find it helpful to rinse my brush in clear water and then dip into a previously painted passage to draw the diluted pigment around some form to soften the effect and model the area. You can see where I have done just this under Sarah's left eye.

Notice that I pull these facial colors into the hairline because I do not want a line of demarcation around her face. The rest of the shadow forms are completed with various mixtures of Winsor blue, alizarin crimson, new gamboge, and burnt sienna.

117

Step 3

Now I use a middle-value combination of alizarin crimson and burnt sienna to model the facial planes. Notice that the direction of the brushstrokes emphasizes the sagging lines of the face, but I must be on guard not to distract from the underlying bony structure.

At this point it's a good idea to let everything dry and use the value scale to check for value relationships. The reflected light will, of course, lighten the outer edge of the shadow on Sarah's cheek, but for the most part, the shadows should be a full 40-percent darker than the initial skin tone.

Step 4

At this stage of the painting things begin to come together and the personality of the model appears. Here I add the final darks and emphasize the facial contours where necessary to achieve a likeness. Next, I dampen the hair area and work wet-into-wet to keep soft, fluid edges. To paint the eyebrows, I first dampen the area and drop pigment into the darkest part of the brow. The brow line must look soft—never hard or pasted on.

Step 5

In this step I add a dark background to act as a foil for her white hair, and use my small oil painter's brush to accent some of the facial lines. Finally, I sketch a white lace collar to add softness to her aged face. The collar is rendered with a very small brush using permanent white designer's gouache (which I find far superior to Chinese white).

Here is Sarah, sweet lady from the past, looking at us through eyes that have seen a time we will never know.

Practice Portraits

This is your opportunity to paint a portrait more or less on your own. Here are photographs of three good-looking men to be your models. Along with the photos are outline drawings of each, my finished paintings, and a list of the colors I used.

Before you begin, please keep in mind that the most important things to consider are the value relationships. Don't worry too much about color at first. If you get excited about color (and that's easy to do) you may forget to be consistent about the value relationships and the careful placement of shadows.

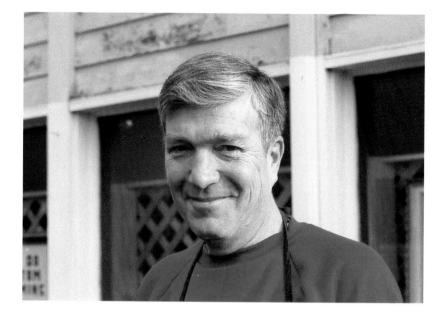

Gene

Gene is the pleasant man who owns the local art supply store. He is every artist's friend, and always has an encouraging word.

Before you paint Gene, study the photograph and try to see for yourself the warm (toward orange) sunlit side of his face. The color becomes cooler on the facial planes that are turned away from direct sunlight.

I painted the background a dark value because I wanted it to act as a foil to call attention to the reflected light on his right cheek. Notice that I just suggested the lattice pattern. It should be enough to entertain, but not so much as to distract from the central figure. The colors I used to paint Gene were: new gamboge, raw sienna, cadmium red, cadmium red deep, burnt sienna, alizarin crimson, sap green, and Winsor blue.

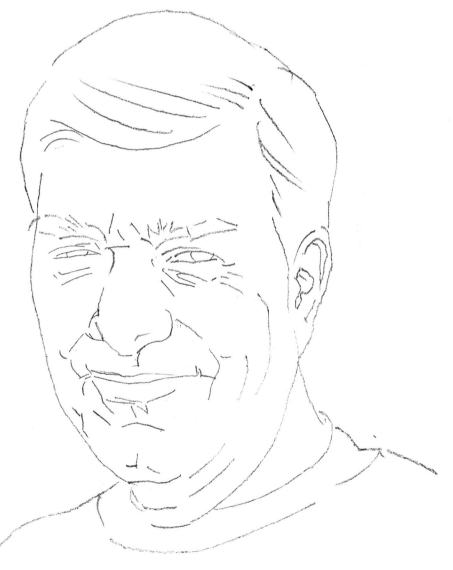

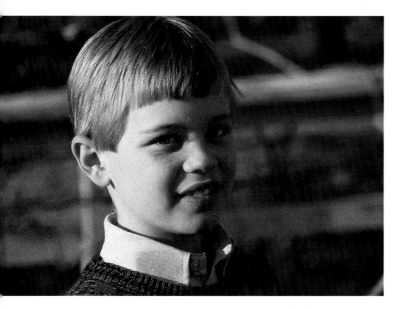

Ben

This charmer is always cooking up some kind of a business venture if he isn't hiding a snake in your desk. I know!

In the photograph of Ben you can probably see that the light golden color of his hair turns cooler at the top. You know to look for this because you know that horizontal surfaces in the sunshine are bluer than vertical ones.

In this painting I wanted the shirt collar to merge with the paper color. There are times when it's possible to just not paint something and let the viewer's eye discover the borders. It's fun to lose edges almost anywhere two areas of the same value meet. I used the following colors to paint Ben: new gamboge, raw sienna, burnt sienna, cadmium red, alizarin crimson, rose madder alizarin, Winsor blue, and cerulean blue.

123

Drummer

This is one of the Indian musicians who provide the music for the annual powwow at the reservation near our home. Everyone has a wonderful time dancing, visiting with friends, and eating the salmon that is smoked alongside the alder coals.

The powwow takes place on a grassy field on a hilltop that is covered with evergreen trees. I painted in a background color reminiscent of the trees, and also to help me give shape to the hat. Can you see any reflected light on the underside of his hat? You know it could be there. Here are the colors I used to paint the drummer: new gamboge, raw sienna, vermilion, cadmium red, alizarin crimson, burnt sienna, burnt umber, Payne's gray, Winsor blue, and ultramarine blue.

124

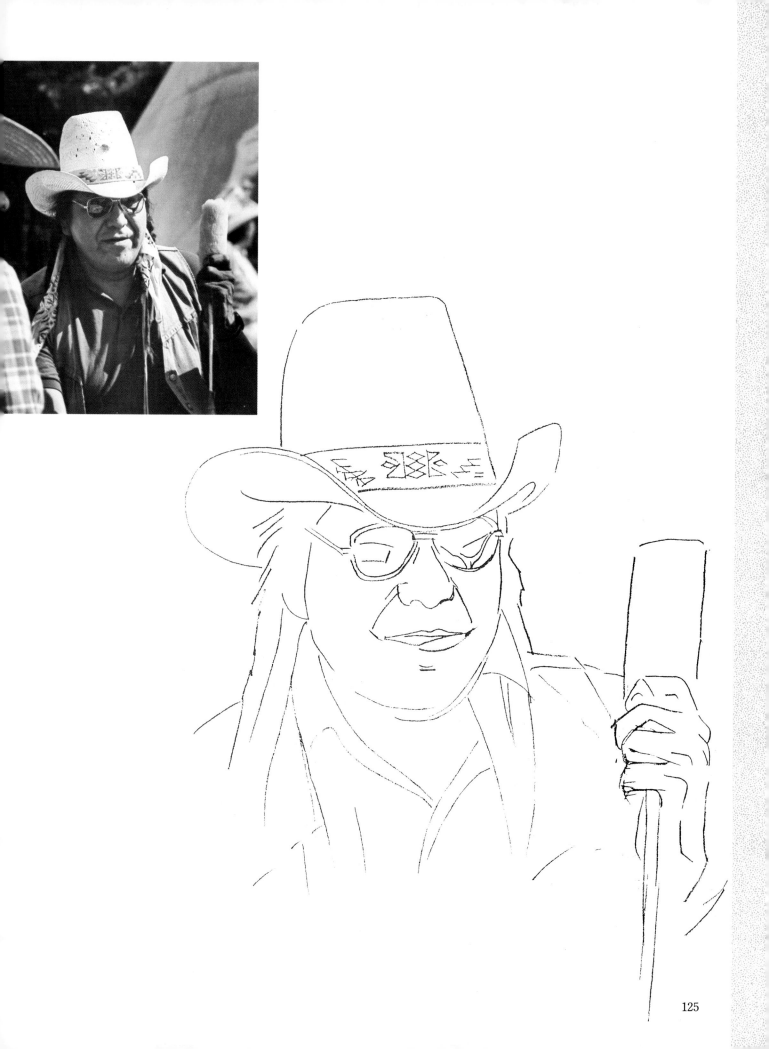

125

Portrait Painter's Questionnaire

The Personal Response

Remember, it takes two to paint a portrait!

- What do I want to say about this person?
- What characteristics do I want to emphasize or express?

Looking at Your Subject

- Where are the warm and cool areas?
- Where are the shadows? Cast shadows?
- What exciting colors do I see?
- Where can I add exciting color?
- Where is the reflected light?
- Can I introduce reflected light I do not see?
- Which edges should be hard? Soft?
- Where can I "lose" an edge?

Composing the Portrait

- Did I make an S.A.T. (stop-and-think) sketch?
- Does my composition convey what I want to say about my subject?
- Is my composition unified?
- Is there a dominant form and color with entertaining contrasts?

Painting the Portrait

Values
- Are the shadows clearly and simply stated?
- Are the value relationships correct?

- Is there a 40-percent difference between sunlit and shaded areas?
- Are cast shadows even darker?

Colors
- Have I kept in mind the laws of light?
 1. Are the areas facing the sun warm in color?
 2. Are the areas oblique to the sun cooler?
 3. Are dark crevices warm in hue?
- Is there reflected light on the shadow side?
- Are my colors clear and luminous?
 1. Did I use pigments that don't contain black?
 2. Did I use clean water, brushes, and a clean palette?
- Are my darks brilliant?
 1. Did I use staining colors with long value range?
 2. Did I use colors from the same side of the color wheel?

Remember, complementary mixtures in values darker than 6 result in mud.

Edges
- Do objects in focus have sharp edges?
- Do hard, angular objects have crisp, distinct edges?
- Do round, soft, or distant objects have soft, indistinct edges?
- Are there "lost" edges where possible, such as between areas of equal value?

10 Steps to a Successful Portrait

Preliminary Drawing

1 Make a preliminary drawing on tracing paper. Draw an oval for the head, and draw the measuring lines that locate the features, starting with the vertical center line.

2 Block in the features. Use as many tracing paper overlays as necessary to clarify and refine the drawing.

3 Refer to the model and locate the shadow side and facial planes on your sketch. Include all the information you think you might need.

4 Write the names of the colors you want to use on your sketch.

5 Draw an X anywhere you want to leave a white. (I sometimes lightly pencil in such an X on my watercolor paper. It is easily removed and can serve as a reminder to avoid painting an area.)

Transfer the Sketch

6 Trace your drawing onto the watercolor paper and check to be sure you have not missed some lines you may need.

Get Ready for Action

7 Be sure you have all the fresh color you need on your palette. It's a good idea to wash off any old pigment every time you begin a new painting.

8 Have these painting accessories close at hand: clean water, facial tissue, a clean paint rag laid next to your clean palette, and a variety of brushes.

Painting

9 Now paint the portrait in this order:
Light facial areas: Paint light facial areas first and let dry. Check the value.
Shadows: Paint the shadow side and cast shadows (40-percent darker than the sunny side) and let dry. Remember cast shadows are somewhat darker.
Facial planes: Paint the facial planes. Think of your brushstrokes as if they were carving the surface.
Finishing touches: Add the darks and the details last. Pick out any highlights with the aid of your acetate frisket and a stiff brush, or with the point of your X-Acto blade.

10 Relax, step back, and look at your portrait. Make any final adjustments. Congratulate yourself for the things you did well. Learn from the things you could do better next time.

4.
Gallery

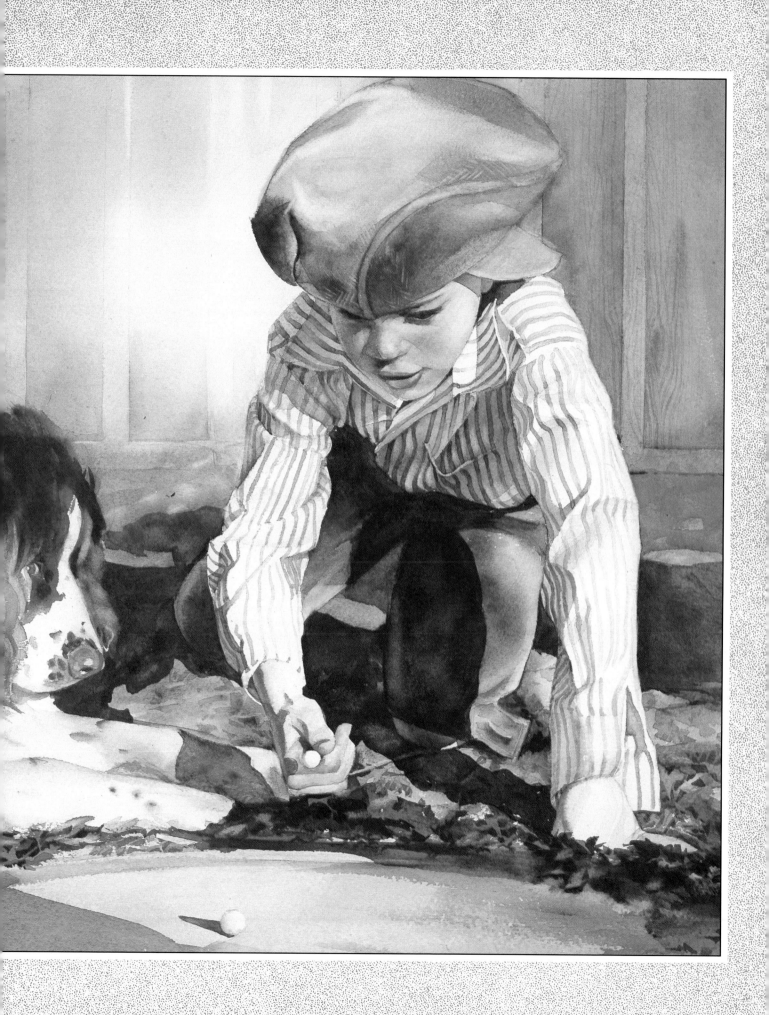

In this section are paintings by artists I admire. The insight gained by studying how other artists cope with the problems of color and design may prove useful in critiquing your own work. Happiness is many things to many people, but for me there is great satisfaction in knowing *why* a painting is successful. Likewise, I want to know when and why a painting *doesn't* work. To paraphrase an old expression, "How can you fix it if you don't know it's broke?"

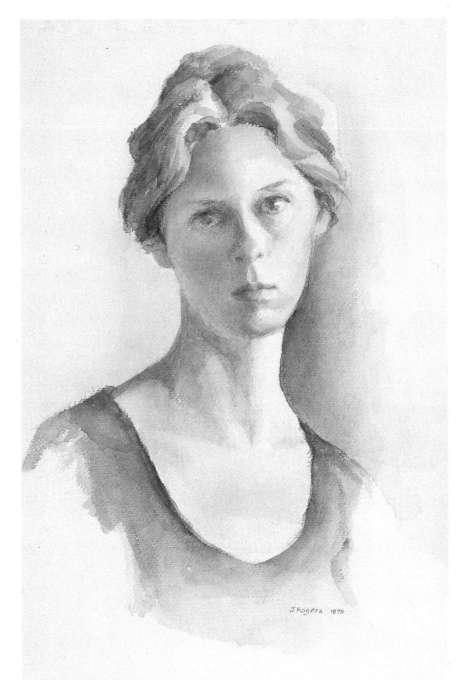

Self Portrait

by Judy Rogers

In this portrait, Judy Rogers presents an intimate study of a quiet and pensive lady. The value relationships are consistent yet subtle, as they might appear in subdued light. Even in this gentle light, you can distinguish the simple shadow form and the suggestion of reflected light on the model's right cheek.

The emotional content of this portrait is unmistakable. Judy says of this painting, "Rather than create an exact likeness, I sought to capture a mood. The portrait reveals a woman not unlike me, yet not me. Her melancholy expression shows her feelings of isolation and loneliness. . . . Her nature is one of quiet resolve. Although her feelings are mine, she is of a universal time and space and portrays a universal experience."

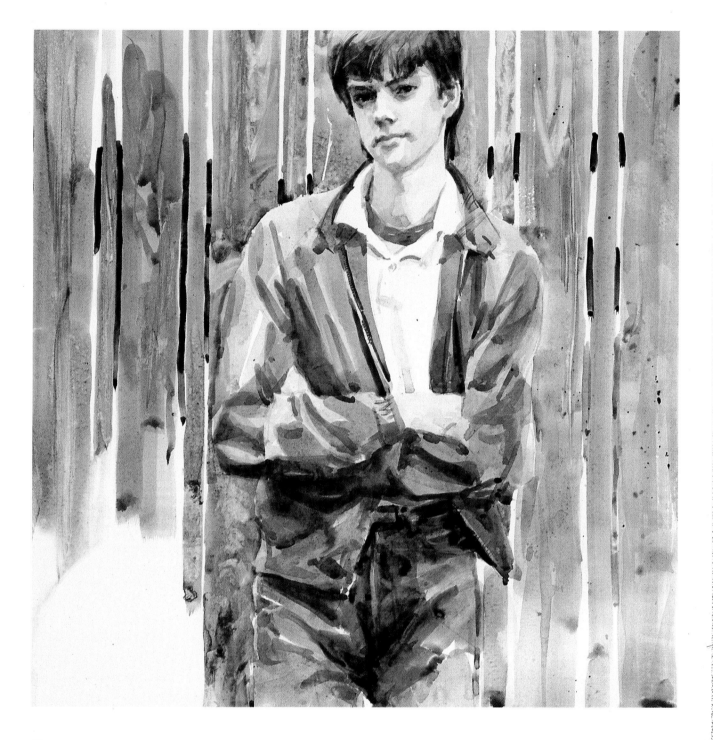

Bruce

by Lynda Lanker

Repetition of vertical forms creates the dominant direction in this water-color by Lynda Lanker. The texture of the board fence provides visual entertainment, while the circular void at the lower left adds interest and contrast. Further contrast and stability are achieved with the sug-

gestion of the horizontal band that anchors both the fence and the figure into a comfortable unit.

If any element of this work were omitted the whole would suffer. To my mind this carefully designed painting masterfully illustrates the principles of composition.

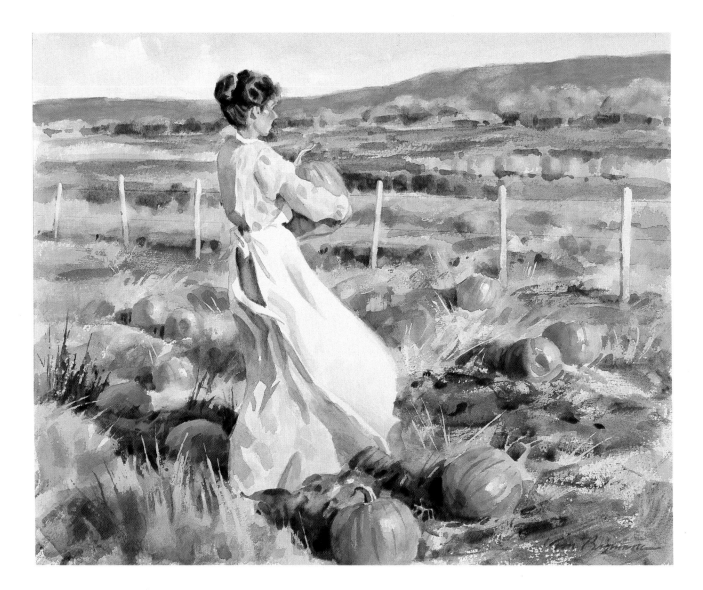

Withered Fields

by Tom Browning

The strong vertical forms of the figure and fence posts dominate the composition of this painting. However, it's the horizontal direction of the field and distant mountains, combined with the model's implied "line of sight" that leave the viewer with a feeling of nostalgia and calm.

Contrast (conflict) provided by the bright value and sharp angle of the apron billowing in the breeze further emphasizes the serenity of the scene.

Notice how the artist uses his understanding of the laws of light to bring sunlit color to the pumpkin patch.

Tom says of his painting that he first goes about establishing "the basic masses and patterns of the areas in shadow." Once those are in, he begins to "work the whole painting, going from one area to another and back again, trying to keep edges soft and a loose overall feeling to help suggest movement."

Prairie Chicken

by Reynold Brown

Here you can see everything we have been talking about coming together in this little jewel of a portrait (it's only 6½″ × 8½″) by the distinguished artist Reynold Brown.

The shadow area is simply stated, and however unwittingly, Reynold observed the "40 percent rule" of value relationships throughout.

Notice the edges—they are soft on the cheek, hard across the nose, and lost at the hairline, with only a suggestion of brows.

One can almost feel the warmth of the sun and delight in the freshness of this watercolor that appears casual and unstudied. The truth is, and I'm sure Reynold would agree, that this portrait is the result of years of study and observation.

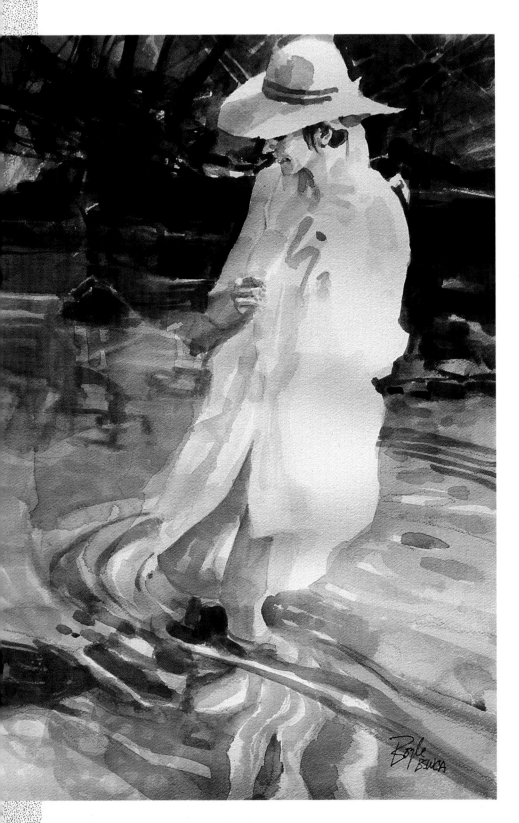

Lady Wading in a Brook
by Neil Boyle

Strictly speaking, this charming watercolor by Neil Boyle is not a portrait, but it is a good example of what can happen when the artist first designs the shapes, and then fits objects into them. The abstract design underlying the representational forms in this painting is unmistakable. I must agree with Maitland Graves who states in his book, *The Art of Color and Design*, that "we may perceive and respond to the design of a picture more than we perceive and respond to its subject matter or representational content." The basic design of a painting is as important as its subject matter.

Here, the figure is handled almost casually, but notice how the cool dark greens at the top of the painting act as a foil for the lady's head and shoulders (the center of interest). Then the artist gradually warms the color, adding more detail in the foreground.

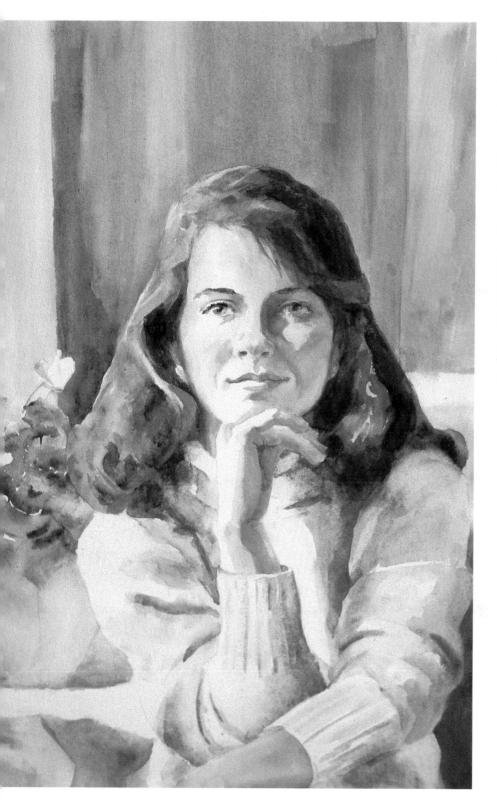

Liz and the Cyclamen

by Katy Grant Hanson

A portrait is the artist's interpretation of the "essence of the sitter." Therefore, the artist is bound to inject something of his or her own personality into the work.

In this portrait, Katy introduces us to a believably warm and friendly young woman. She is looking squarely at the viewer, and appears to be the sort of person in whom you could confide.

The oval of the model's face, which is framed by her dark hair, rightfully commands the center of attention. Secondary direction and interest is provided by the vertical thrust of the model's right arm and is repeated in the vertical background bands.

Katy says that wherever possible, she tries to capture the essence of the person, object, or scene she is painting.

Jessica
by David DeMatteo
Dave enjoys an enviable reputation as a landscape artist. He's a keen observer of color and form as evidenced in this beautiful portrait of his daughter. Her personality shines through, as does her father's affection.

The sunlit side of Jessica's head is relatively close in value to the shadow side, as is appropriate to indoor lighting. Still, these shadow forms are simple and easily read. I especially like the variety of color used to describe Jessica's hair.

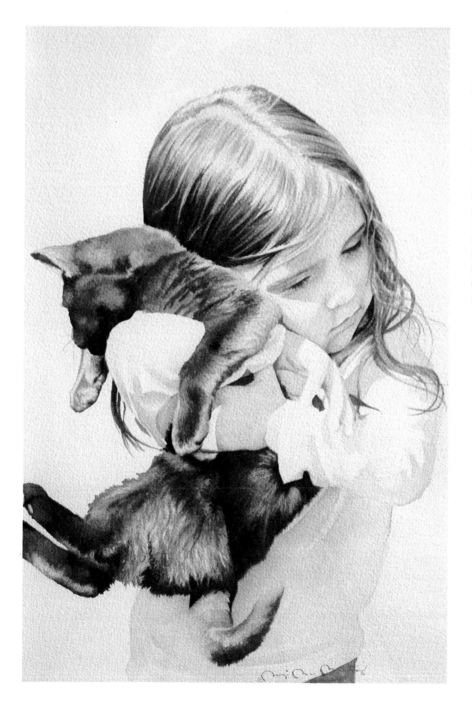

Cuddles

by Suzi Mather

It's true that there is no one way to approach a watercolor portrait. Suzi tells us that she works light to dark in the light areas of the portrait, but in the areas with deep values, she likes to work dark to light. She establishes the value using Prussian blue, and once that color is dry, she adds raw sienna, alizarin crimson, and sometimes a touch of new gamboge for warmth. This technique ensures the color harmony especially evident in the hair of the child, and the cat's fur. The warmth and appeal of a child and her pet adds to the charm of this delightful portrait.

Conclusion

All of us who paint will, now and then, hit a dry spell, when nothing turns out right. When this happens, don't get discouraged. Get away from it for a while, and when you return you will be better than ever. Painting is hard work and it requires energy and a clear mind.

It's comforting to know that success in painting is the result of a lot of hard work and practice. No amount of wishful thinking can make you a better painter—only honest effort can do that. Without exception, the fine artists I have met don't boast of their ability—they know there is always more to learn, and room to grow.

In the next pages, I've included the full-size line drawings I used for many of the portraits in this book. They are an invitation to you to follow along with me as I paint step-by-step.

In the bibliography, I've listed the books on drawing, watercolor, and portraiture that have helped me. Each book offers lessons that I think will help you be a better portrait painter. I highly recommend them.

One last thought. Frederic Whitaker said "a painter . . . seldom makes his mark until middle age—and sometimes a great deal later. Many artists have done their best work after seventy."

I like that! Look at all the time we have. As long as we live we can enjoy the challenge and fulfillment of painting in watercolor.

(right) "Don" 15 x 22

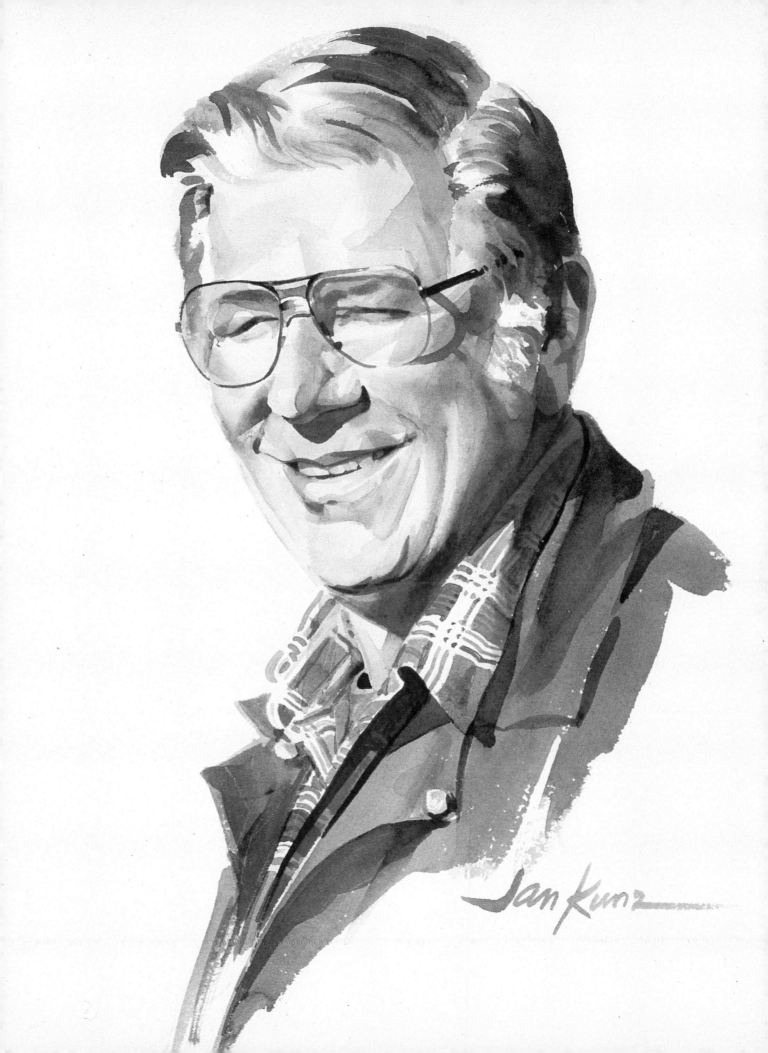

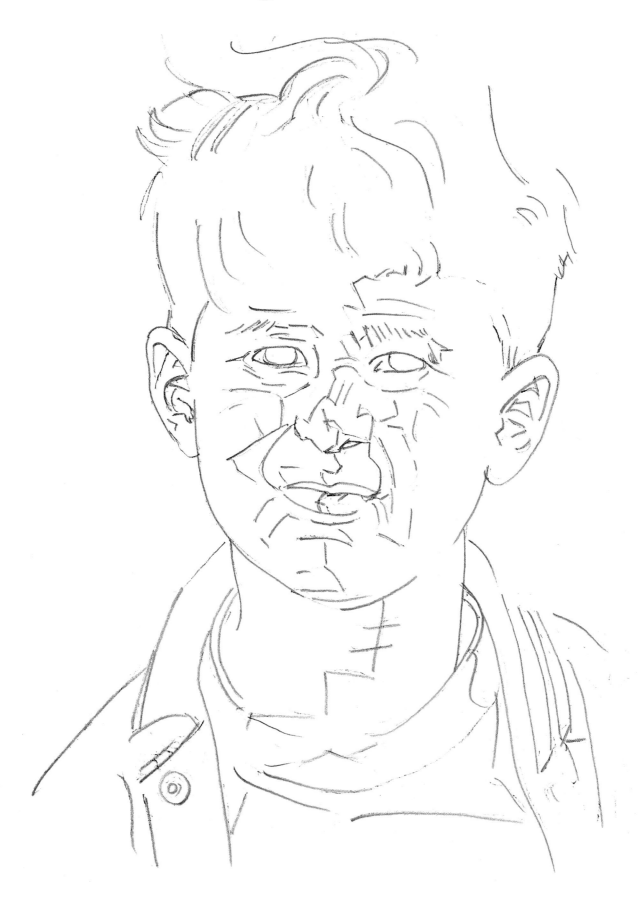

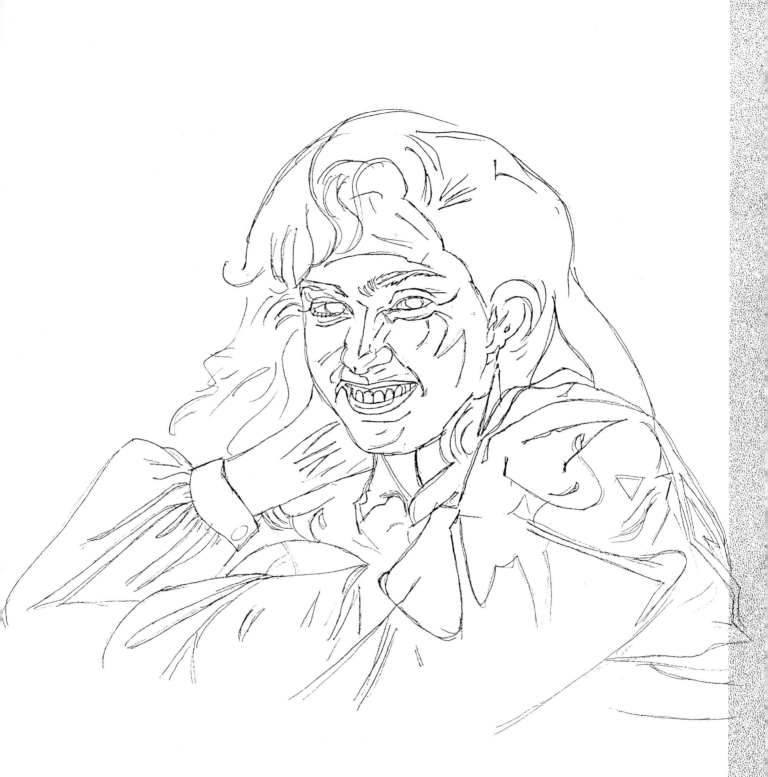

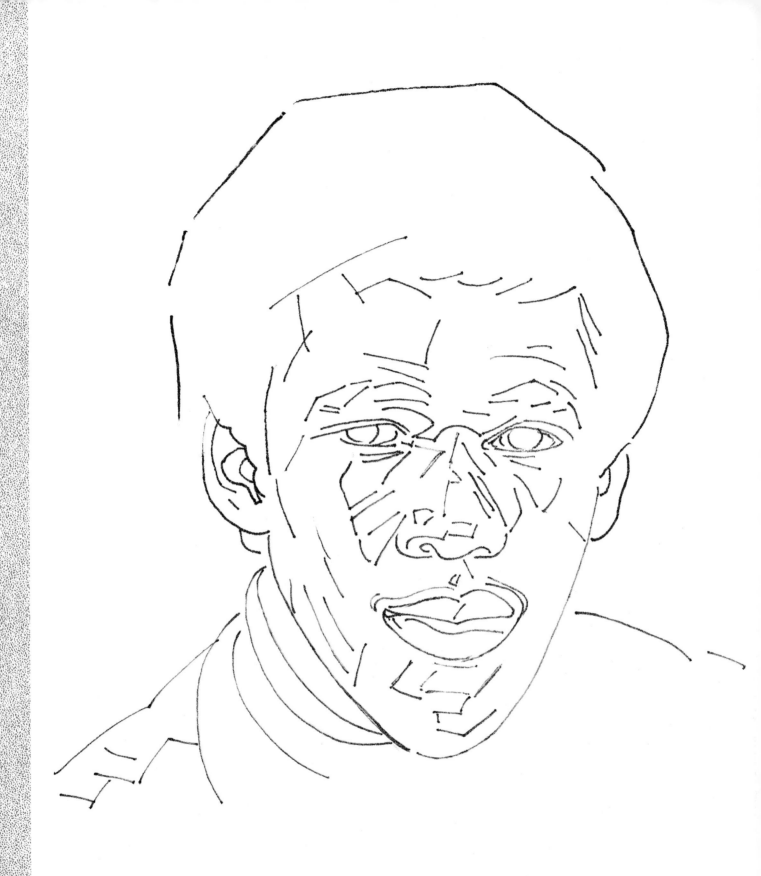

142

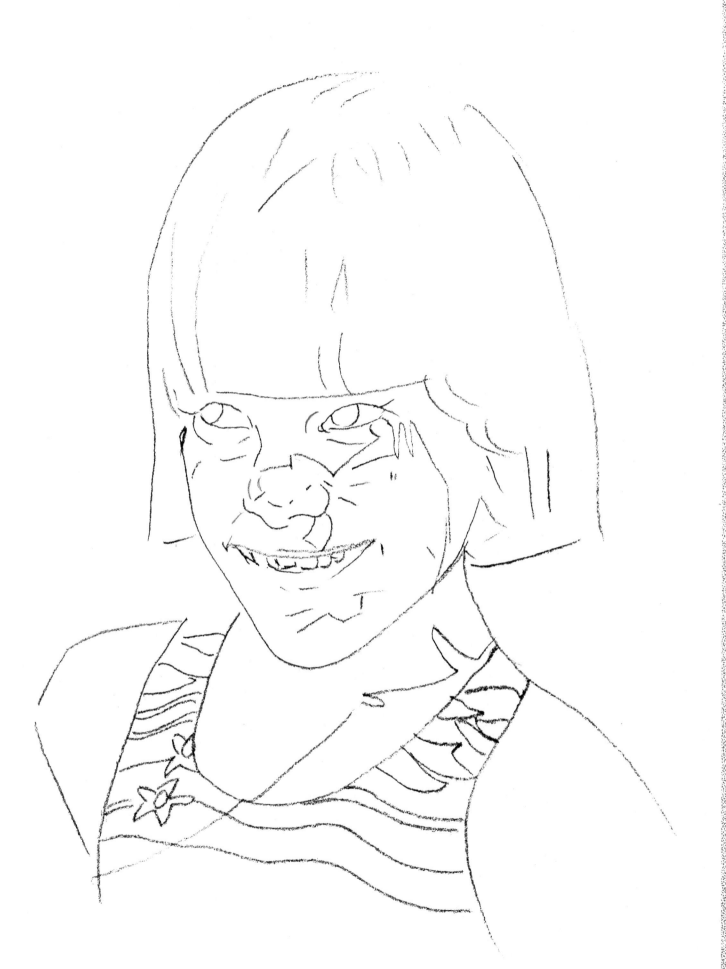

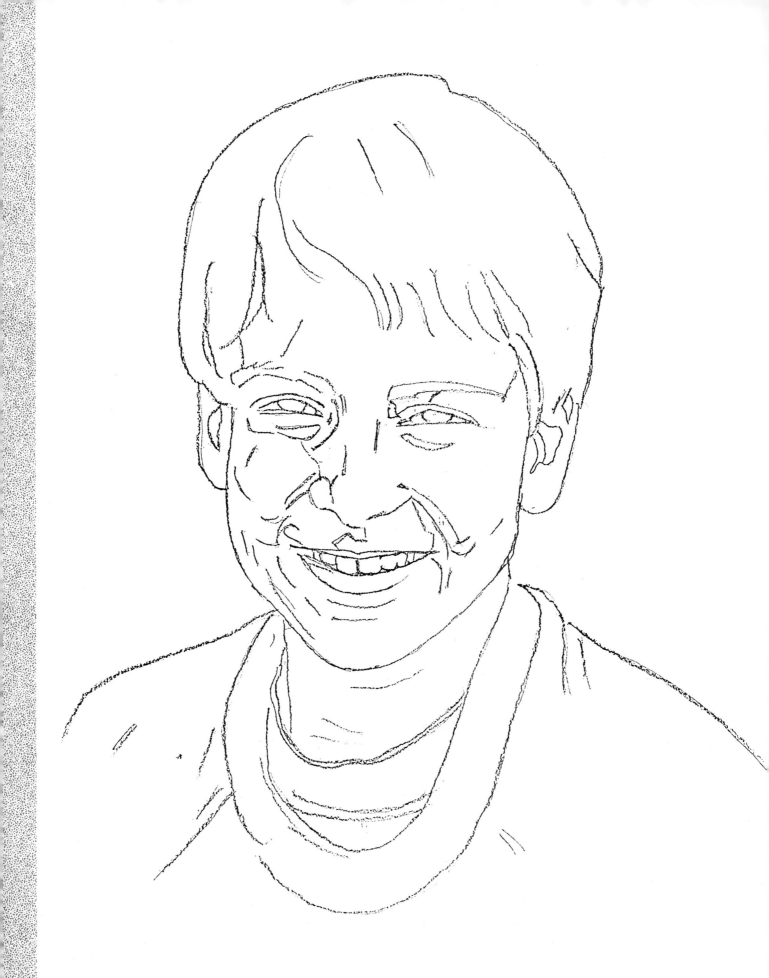

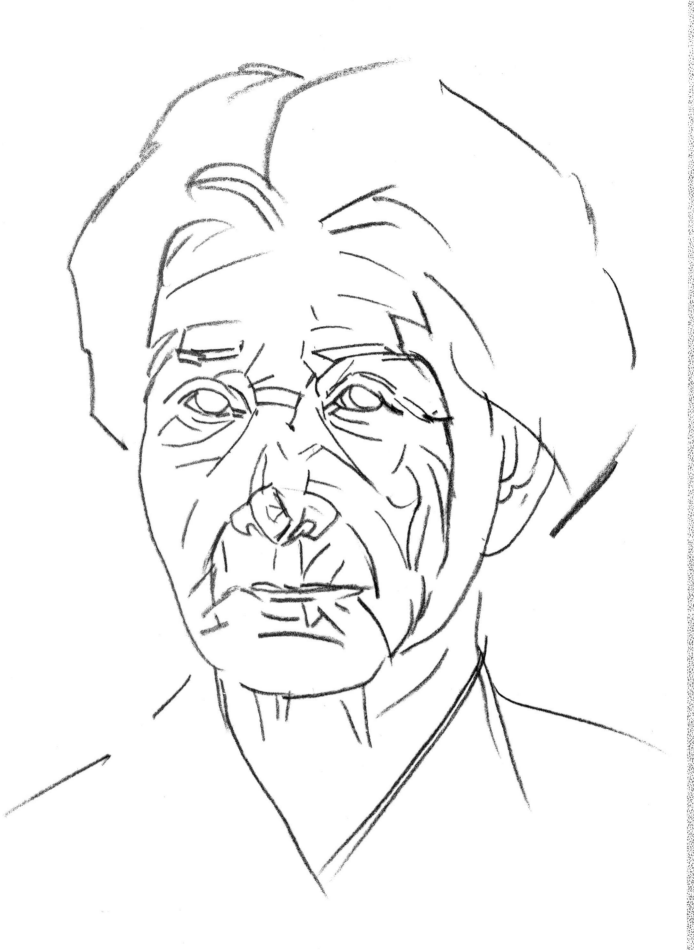

Bibliography

For a scholarly, in-depth study of *composition and design,* this book is superb. It's heavy reading, but well worth the time!

Graves, Maitland. *The Art of Color and Design.* New York: McGraw-Hill, 1951.

These books have well-written chapters on the elements and principles of design, and are easy to read and understand.

Couch, Tony. *Watercolor: You Can Do It!* Cincinnati: North Light Books, 1987.

Whitney, Edgar A. *A Complete Guide to Watercolor Painting.* New York: Watson-Guptill, 1972.

Wood, Robert E. *Watercolor Workshop.* New York: Watson-Guptill, 1975.

I wish every beginning watercolor student could read the following books. The first two describe the effects of *color in sunlight.* All three books are filled with no-nonsense, basic information on many aspects of watercolor painting.

Pierce, Gerry. *Painting the Southwest Landscape.* New York: Reinhold, 1977.

Schimmel, William B. *Watercolor: The Happy Medium.* New York: Reinhold, 1961.

Whitaker, Frederic. *Whitaker on Watercolor.* New York: Reinhold, 1963.

This book provides a comprehensive guide to understanding the structural framework of the *human form.*

Berry, William A. *Drawing the Human Form.* New York: Van Nostrand Reinhold, 1977.

You will enjoy Charles Reid's fresh, wet approach to *watercolor portraits* and figure drawing.

Reid, Charles. *Portrait Painting in Watercolor.* New York: Watson-Guptill, 1977.

Reid, Charles. *Figure Painting in Watercolor.* New York: Watson-Guptill, 1976.

For pure inspiration these books contain beautiful portraits by contemporary painters. Most of the portraits are in oil, but there is much to learn about *expression and presentation* from these artists.

Balcomb, Mary N. *Nicolai Fechin.* Flagstaff, AZ: Northland Press, 1985.

Kinstler, Everett R. *Painting Faces, Figures, and Landscapes.* New York: Watson-Guptill, 1981.

This next book has a nice chapter on heads and hands that helps make the complexities of drawing them easier to understand.

Reed, Walt. *The Figure.* Cincinnati: North Light Books, 1976.

Both of J. Everett Draper's books have lots of good information on painting the figure in watercolor, including some pointers about the head and face that are useful to the portrait artist.

Draper, J. Everett. *Putting People in Your Paintings.* Cincinnati: North Light Books, 1985.

Draper, J. Everett. *People Painting Scrapbook.* Cincinnati: North Light Books, 1988.

Here's a paperback book with lots of interesting tips on drawing and painting the features in particular.

Hamm, Jack. *Drawing the Head and Figure.* New York: Perigee Books, 1963.

This is a book with twenty-five different portraits painted in many different mediums. A useful source for ideas on new approaches to portraiture. Good for inspiration.

Rodwell, Jenny. *Painting Portraits.* Cincinnati: North Light Books, 1986.

Next is a good book on the underlying structure of the head, with tips on drawing techniques. It's illustrated with heads and faces of all ages and races.

Gordon, Louise. *How to Draw the Human Head: Techniques and Anatomy.* New York: Penguin Books, 1977.

This book is not about portraiture, but it covers many pertinent topics very well, including the treatment of planes, luminosity, and calligraphy—the use of line to add interest. It's both informative and a joy to read.

Webb, Frank. *Watercolor Energies.* Cincinnati: North Light Books, 1983.

Finally, here's a photographic sourcebook that includes a very useful collection of faces, features, and hands.

Ruby, Erik A. *The Human Figure: A Photographic Reference for Artists.* New York: Van Nostrand Reinhold, 1974.

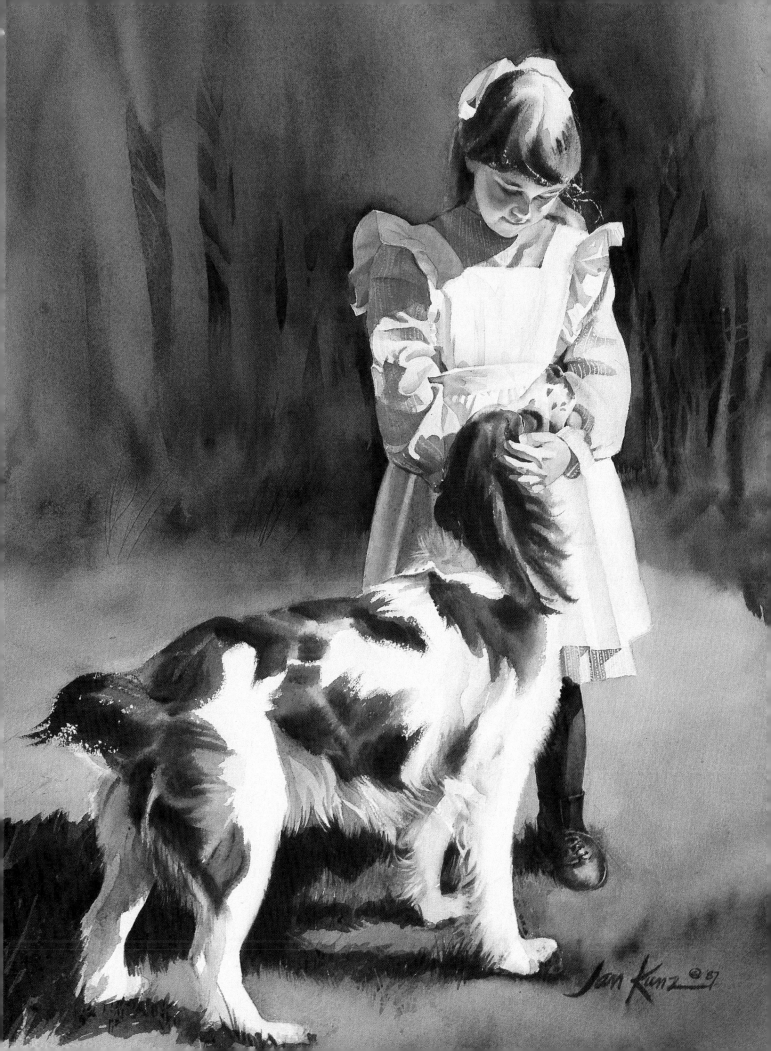

Index

Adornments, 36, 66, 96, 119

Background, 100, 119, 121, 124
Brushes
 recommendations on, 4
 special uses of, 4, 95, 115
 usage of, 67, 92, 97
Brushstrokes
 effects of, 39, 42, 118
 placement of, 68

Chinese White, 119
Color
 application techniques, 57, 91, 114
 on palette, 9, 58
 on paper, 36, 118
 temperature, 35, 46, 48-49, 50, 55, 58, 68, 79, 80, 123
 value, 56, 80
 wheel, 55
Colors
 accenting with, 52, 57. See also Highlighting.
 appearance of (on varying surfaces), 58
 essential watercolor, 9
 lifting, 5, 111
 mixing, 55, 58, 114
 opaque, 51, 52
 principles of, 45, 50-55
 staining, 53
 transparent, 39, 51
 See also Shadows, colors in.
Complementary colors
 mixing of, 56-57, 91, 113
 nature of, 50
Composition, 83-87, 131, 132
Contrast, 84, 132
Corrections, making, 4, 5, 37, 63, 92, 93, 111

Design
 abstract, 134
 principles of, 83-87
Detail
 omitting, 22, 76
 painting, 39, 69, 97
 sketching, 90
 See also Adornments, Highlighting.
Dominance, 84
Drawing boards, 7

Ears, 15, 25, 80
Edges
 controlling, 67
 "losing," 123
 protecting, 5
 role of, 31
 softening, 38, 64, 95, 98, 115, 118
 treatment of, 92, 109, 133
Egghead model
 for head and feature positioning, 14-15, 18-21
 for light and shadow, 48-49, 78, 80
 for reflected light, 59
Eyebrows, 14, 65, 118

Eyes, 14, 22, 58

Facial features
 modifications of, 18-21, 62
 positioning of, 14-17, 90, 127
 positioning problems of, 26-27
Facial planes
 identifying, 5, 32, 40, 80
 painting, 38, 127
Finishing touches, 127. See also Detail, Highlighting.
Focal point, 84-85, 86, 135
Forty percent rule, 33-35, 40, 48, 91, 133. See also Shadow.
Friskets
 acetate, 4, 5, 111, 127
 liquid, 5, 68
 removing, 68

Glazing, 53, 63, 101
"Glow," keys to, 33, 40, 49, 57, 60, 61, 91
"Golden Section," 86. See also Focal point.
Gouache, 119
Graphite paper, handmade, 8-9. See also Transfer techniques.

Harmony of proportions, 86
Head, 14-21
Highlighting, 5, 41, 65, 111, 113, 127. See also Colors, accenting with.
Horizontal surfaces, 46, 68, 79, 123
Hue, 36, 50

Intensity, 36, 50, 52-53

Layering
 as painting technique, 59
 as sketching technique. See Sketching.
Light, laws of, 45-49, 68, 78, 79, 93, 132. See also Reflected light.
Lighting
 artificial, 40, 43, 136
 models and, 78
 modification of, 40
 sources of, 32, 40, 61
 subdued, 116, 130
 See also Sunlight.

Masking materials, removing, 68. See also Friskets.
Mirroring, 46
Mixing colors. See Colors.
Models, 73-81
 child, 74, 76
 lighting for, 78
 observing, 74, 76, 78
 older, 42
 photographs as, 40, 66, 74, 76-77, 112
 posing, 75, 85
Mood, conveying, 75, 87, 130
Mouth, 15, 24, 62

Nose, 15, 23

Overlays. See Sketching.

Painting tools, 4-5, 127
Palette, 4, 58
Paper, 6-7
Personality, expressing, 80, 87, 101, 104
Pigments, 51, 54. See also Color, Colors.
Portraiture, 13, 74, 83
Posing models, 74-75. See also Composition.
Proportion, facial, 14-17

Reflected light
 coloring of, 59, 79
 "glow" of, 33, 49, 57, 91
 invention of, 77, 116
 qualities of, 32, 35, 46-47
Roundness, 49, 111

Shadows
 cast, 34, 43, 46, 48, 57
 characteristics of, 33, 46
 colors in, 33, 34-35, 46-47, 55-57, 60-61, 78-79
 identifying, 40, 76, 90, 112, 127
 shaping with, 32, 38, 59, 67, 132
 tips on painting, 57, 65, 127
Shape, 31, 32
Sketching
 tips on, 16-17, 79, 89
 tools for, 5
 using overlays for, 5, 8, 28-29, 66, 90, 96, 112, 127
Skin tones, 58, 66
Stop-and-think (S.A.T.) sketch, 78, 87, 96, 112
Stretching paper, 6-7
Sunlight
 creating the illusion of, 40, 45, 48-49, 50
 effects of, 36, 43, 45

Teeth, 62, 63
Three dimensions, illusion of, 31, 34
Tracing paper, 5, 28-29. See also Sketching.
Transfer techniques, 5, 28, 127

Unity of composition, 84

Value
 checking, 34, 36, 40, 118
 exercise in, 36-39, 41-43, 108-111
 role of, 1, 31, 32, 50
Value range, 50-51, 52-53
Value scale, 33
Vertical surfaces, 46, 68, 79, 123
Vignette, 86, 90
Visual entertainment, 84, 100, 121, 131

Washes, mixing, 4
Water, use of, 5, 58, 59
Water-based paint, types of, 9
Wetting techniques, 38, 39

Improve your skills, learn a new technique, with these additional books from North Light

Business of Art

Artist's Friendly Legal Guide, by Floyd Conner, Peter Karlan, Jean Perwin & David M. Spatt $18.95 (paper)

Artist's Market: Where & How to Sell Your Graphic Art, (Annual Directory) $19.95 (cloth)

The Complete Guide to Greeting Card Design & Illustration, by Eva Szela $27.95 (cloth)

Handbook of Pricing & Ethical Guidelines, 7th edition, by The Graphic Artist's Guil $22.95 (paper)

Legal Guide for the Visual Artist, Revised Edition by Tad Crawford $18.95 (paper)

Licensing Art & Design, by Caryn Leland $12.95 (paper)

Make It Legal, by Lee Wilson $18.95 (paper)

Art & Activity Books For Kids

Draw!, by Kim Solga $11.95

Paint!, by Kim Solga $11.95

Make Prints!, by Kim Solga $11.95

Make Gifts!, by Kim Solga $11.95

Watercolor

Basic Watercolor Techniques, edited by Greg Albert & Rachel Wolf $14.95 (paper)

Big Brush Watercolor, by Ron Ranson $22.95 (cloth)

Buildings in Watercolor, by Richard S. Taylor $24.95 (paper)

The Complete Watercolor Book, by Wendon Blake $29.95 (cloth)

Fill Your Watercolors with Light and Color, by Roland Roycraft $27.95 (cloth)

Flower Painting, by Paul Riley $27.95 (cloth)

Getting Started in Watercolor, by John Blockley $19.95 (paper)

How To Make Watercolor Work for You, by Frank Nofer $27.95 (cloth)

Jan Kunz Watercolor Techniques Workbook 1: Painting the Still Life, by Jan Kunz $12.95 (paper)

Jan Kunz Watercolor Techniques Workbook 2: Painting Children's Portraits, by Jan Kunz $12.95 (paper)

The New Spirit of Watercolor, by Mike Ward $21.95 (paper)

Painting Nature's Details in Watercolor, by Cathy Johnson $21.95 (paper)

Painting Watercolor Portraits That Glow, by Jan Kunz $27.95 (cloth)

Splash I, edited by Greg Albert & Rachel Wolf $29.95

Starting with Watercolor, by Rowland Hilder $24.95 (cloth)

Tony Couch Watercolor Techniques, by Tony Couch $14.95 (paper)

Watercolor Impressionists, edited by Ron Ranson $45.00 (cloth)

Watercolor Painter's Solution Book, by Angela Gair $19.95 (paper)

Watercolor Painter's Pocket Palette, edited by Moira Clinch $15.95 (cloth)

Watercolor: Painting Smart, by Al Stine $27.95 (cloth)

Watercolor—The Creative Experience, by Barbara Nechis $16.95 (paper)

Watercolor Tricks & Techniques, by Cathy Johnson $24.95 (cloth)

Watercolor Workbook, by Bud Biggs & Lois Marshall $19.95 (paper)

Watercolor: You Can Do It!, by Tony Couch $26.95 (cloth)

Webb on Watercolor, by Frank Webb $29.95 (cloth)

The Wilcox Guide to the Best Watercolor Paints, by Michael Wilcox $24.95 (paper)

Mixed Media

The Artist's Complete Health & Safety Guide, by Monona Rossol $16.95 (paper)

Basic Drawing Techniques, edited by Greg Albert & Rachel Wolf $14.95 (paper)

Blue and Yellow Don't Make Green, by Michael Wilcox $24.95 (cloth)

Bodyworks: A Visual Guide to Drawing the Figure, by Marbury Hill Brown $24.95 (cloth)

Business & Legal Forms for Fine Artists, by Tad Crawford $12.95 (paper)

Capturing Light & Color with Pastel, by Doug Dawson $27.95 (cloth)

Colored Pencil Drawing Techniques, by Iain Hutton-Jamieson $24.95 (cloth)

The Complete Acrylic Painting Book, by Wendon Blake $29.95 (cloth)

The Complete Guide to Screenprinting, by Brad Faine $24.95 (cloth)

The Creative Artist, by Nita Leland $27.95 (cloth)

Creative Basketmaking, by Lois Walpole $24.95 (cloth)

Creative Painting with Pastel, by Carole Katchen $27.95 (cloth)

Decorative Painting for Children's Rooms, by Rosie Fisher $29.95 (cloth)

The Dough Book, by Toni Bergli Joner $19.95 (cloth)